MICHAEL POLIZA

BABY ANIMALS

teNeues

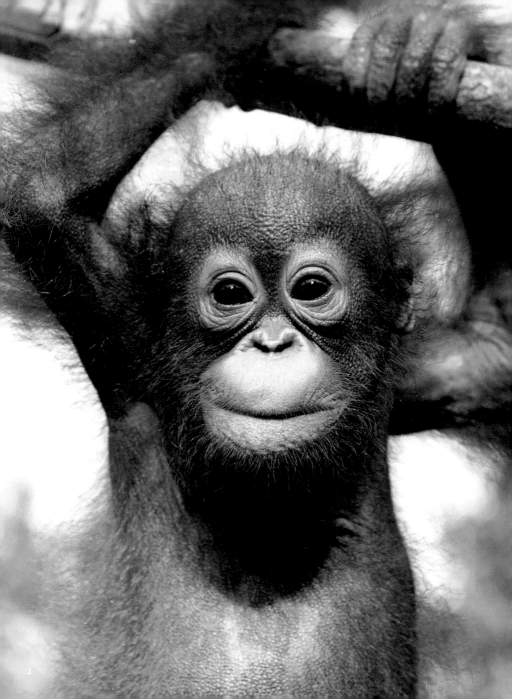

INTRODUCTION

Endlessly cute, playful, and curious, baby animals have captured our hearts since the beginning of time. From bright-eyed monkeys scurrying up trees and nimble meerkats scampering around in the bush, to plump little hippos splashing in water, baby creatures are so adorable that it's hard to imagine them growing up to become fierce predators or unassuming prey, battling it out for survival in nature's circle of life.

Since the publication of his book *Africa* in 2006, photographer Michael Poliza has continued to turn his lens towards the majestic beauty of nature and wildlife. With a knack for getting up close and personal with (at times dangerous) wild creatures, he never fails to capture images that evoke the magic and wonder of natural landscapes and their inhabitants.

In this book, Poliza presents a selection of some of his captivating photographs of lovable, mainly African, baby animals, many of which have never been published before. Page by page, heartwarming images of a diverse array of baby beasts and the remarkable moments of early life wait to be uncovered. Fuzzy lion cubs rambunctiously frolic on the savanna and climb upon fallen logs. Elephant youngsters are lovingly nursed by their protective mothers. And a newborn zebra gingerly stands up on its skinny, spindly legs, navigating its way into the world for the very first time.

Brimming with cute and colorful photographs, *Baby Animals* is bound to delight anyone with a love for nature and its darling babies.

EINLEITUNG

Niedlich, verspielt und neugierig – schon immer haben Tierkinder unser Herz gerührt. Ob großäugige Affen, die Bäume hochflitzen, flinke Erdmännchen, die in Büschen herumwuseln oder plumpe Nilpferdkinder, die sich ins Wasser platschen lassen. Dass diese süßen Jungen in wenigen Jahren gefährliche Jäger oder geschickte Beutetiere im ewigen Überlebenskampf werden, mag man sich kaum vorstellen.

Seit seinem Buch *Africa* von 2006 hat der Fotograf Michael Poliza die majestätische Schönheit der Natur und der Tierwelt immer wieder in den Fokus genommen. Sein Geschick, mit dem er sich den beizeiten höchst gefährlichen Wildtieren nähert, erlaubte ihm Bilder zu schießen, die die Magie der natürlichen Landschaften und ihrer Bewohner beschwören.

Für diesen Band hat Poliza eine Auswahl seiner betörenden Bilder vorwiegend afrikanischer Tierkinder zusammengestellt, von denen viele bisher noch nie veröffentlicht wurden. Beim Blättern stößt man auf immer neue herzerwärmende Kinderfotos einer Vielzahl von Tierarten und erfährt mehr über deren Verhaltensweisen. Struppige Löwenbabys toben ausgelassen in der Savanne und klettern auf Baumstämmen herum. Jungelefanten werden liebevoll von ihrer Mutter umsorgt, und ein frischgeborenes Zebra macht auf dürren Beinen seine ersten Schritte.

Randvoll mit süßen und farbenfrohen Bildern wird *Baby Animals* jeden erfreuen, der die Natur und seine jüngsten Mitglieder liebt.

INTRODUCTION

Toujours adorables, joueurs, curieux, les bébés animaux nous font fondre depuis la nuit des temps. Singes malicieux grimpant aux arbres, suricates agiles gambadant dans la brousse ou jeunes hippopotames lourdauds barbotant dans l'eau, ces petits sont tellement mignons qu'on a bien du mal à imaginer qu'un jour ils seront de féroces prédateurs ou au contraire de simples proies luttant pour leur survie dans le cycle de la vie.

Depuis la publication de son livre *Africa* en 2006, le photographe Michael Poliza n'a de cesse d'immortaliser la beauté magique de la nature, ainsi que de la faune et de la flore sauvages. Doté d'un véritable talent pour s'approcher au plus près d'animaux sauvages parfois dangereux, et nouer avec eux des relations étroites, il réalise des clichés qui sont autant d'hommages à la magie des paysages naturels et de leurs hôtes.

Dans cet ouvrage, Michael Poliza présente une sélection de photographies époustouflantes d'adorables bébés animaux, essentiellement réalisées en Afrique et inédites pour la plupart. Page après page, le lecteur découvre des images qui font chaud au cœur, présentant une grande diversité de tout jeunes animaux et les instants extraordinaires des débuts de la vie. De patauds lionceaux s'ébattent bruyamment dans la savane et escaladent des arbres tombés à terre. Des mamans éléphants protectrices s'occupent tendrement de leurs petits. Et un jeune zèbre qui vient de voir le jour se dresse précautionneusement sur ses frêles pattes pour faire ses tout premiers pas.

Foisonnant de photographies aux riches couleurs plus émouvantes les unes que les autres, *Baby Animals* fera le bonheur de tous ceux qui aiment la nature et ses adorables bébés animaux.

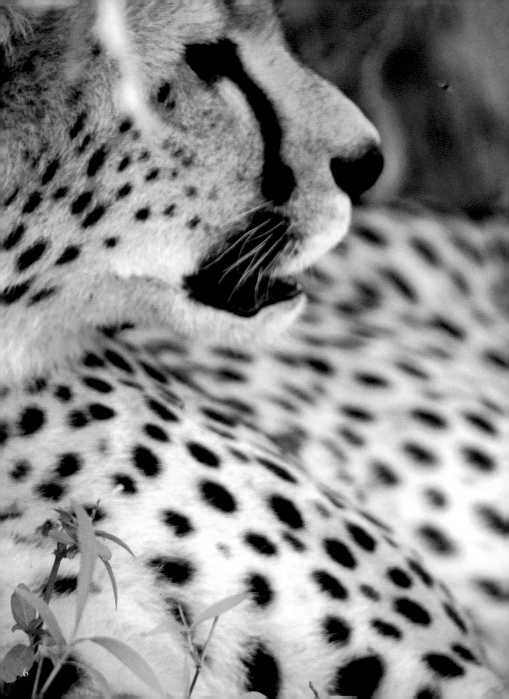

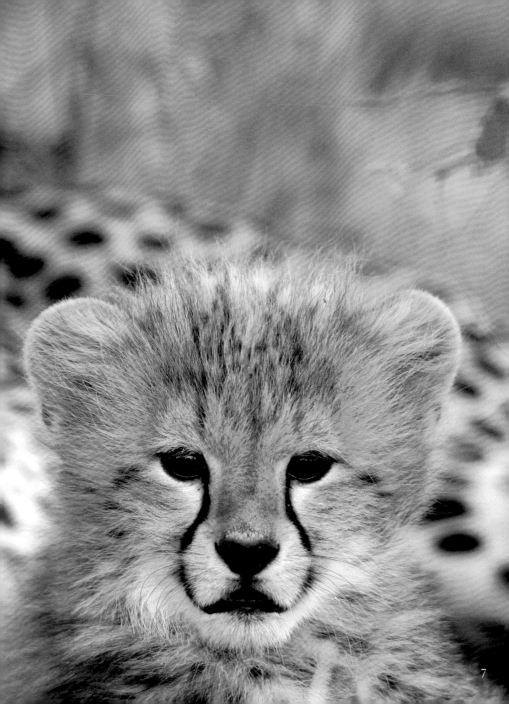

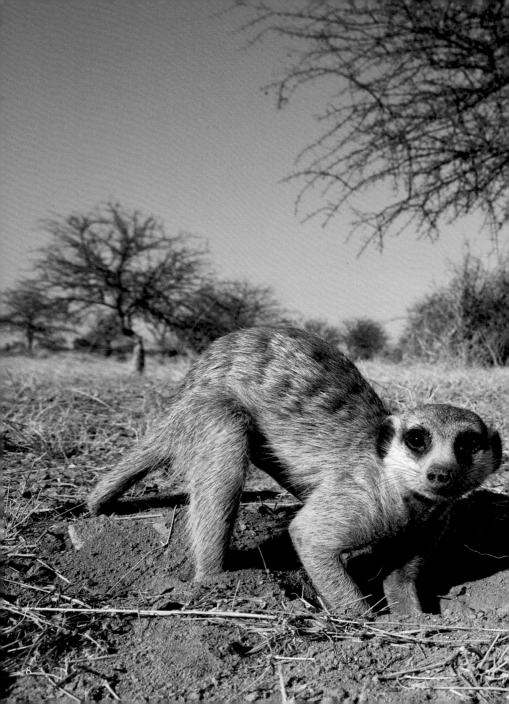

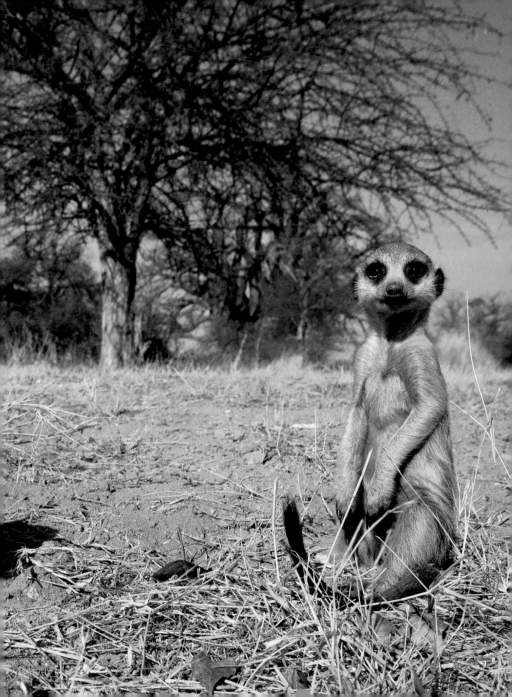

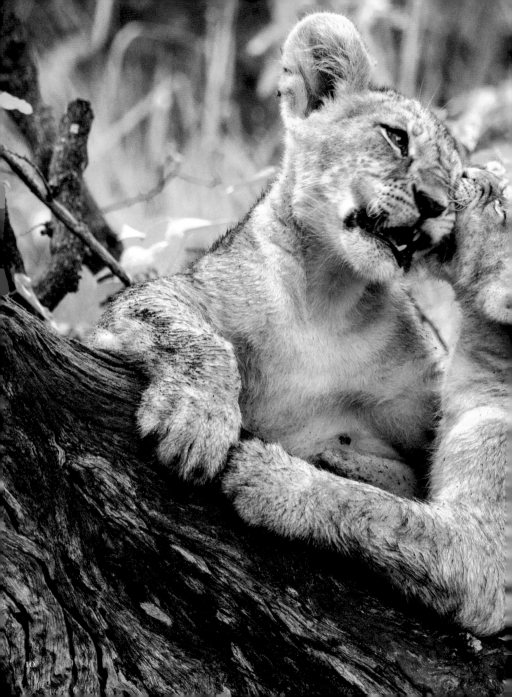

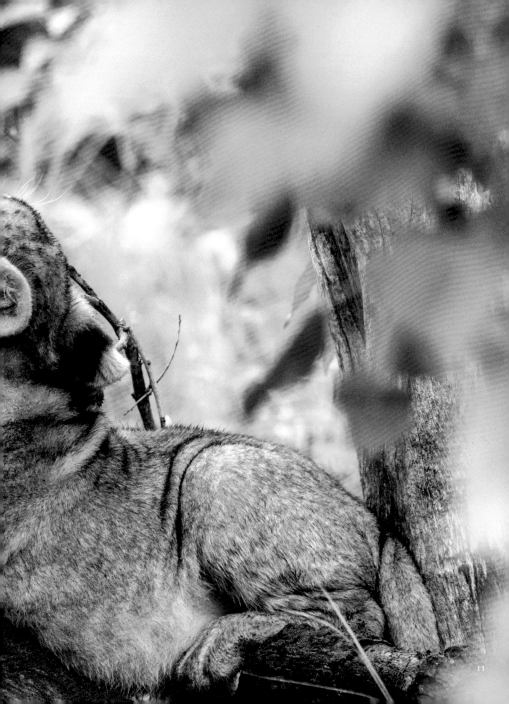

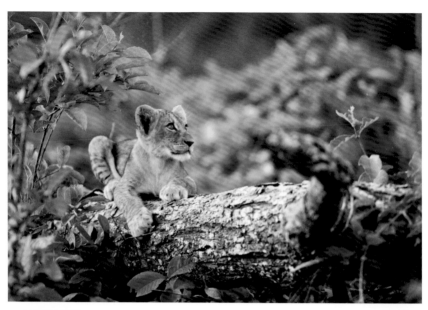

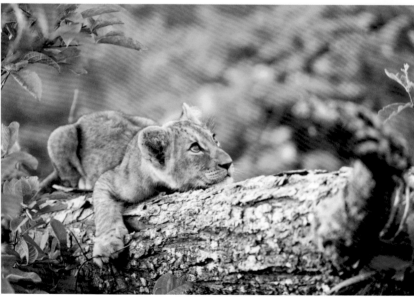

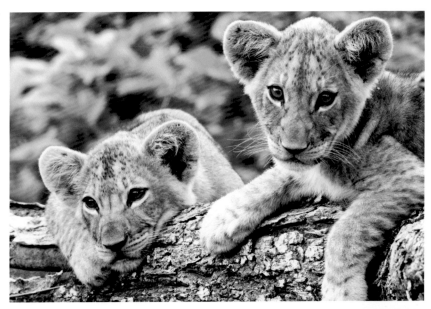

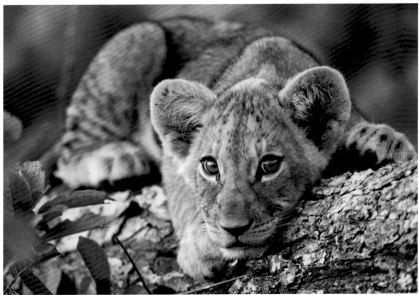

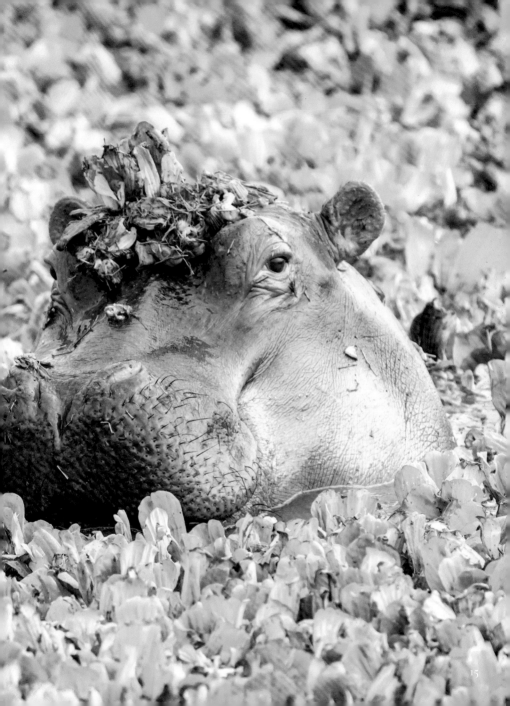

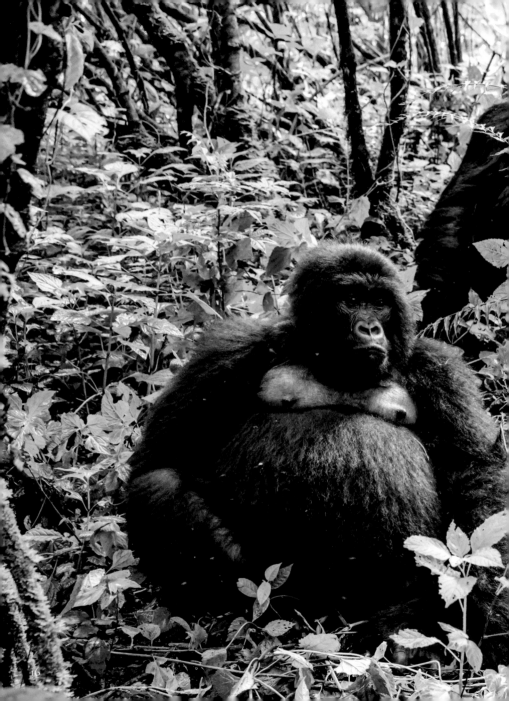

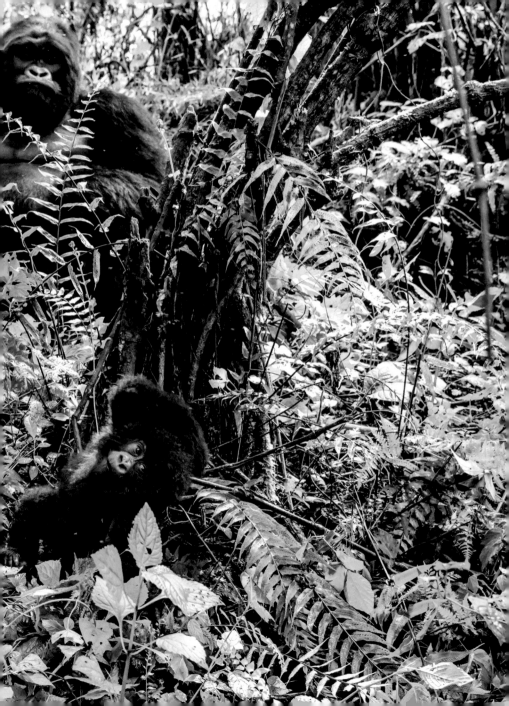

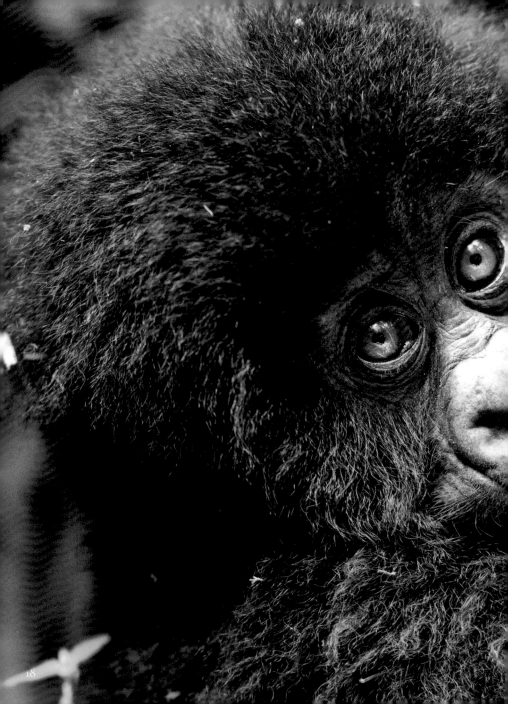

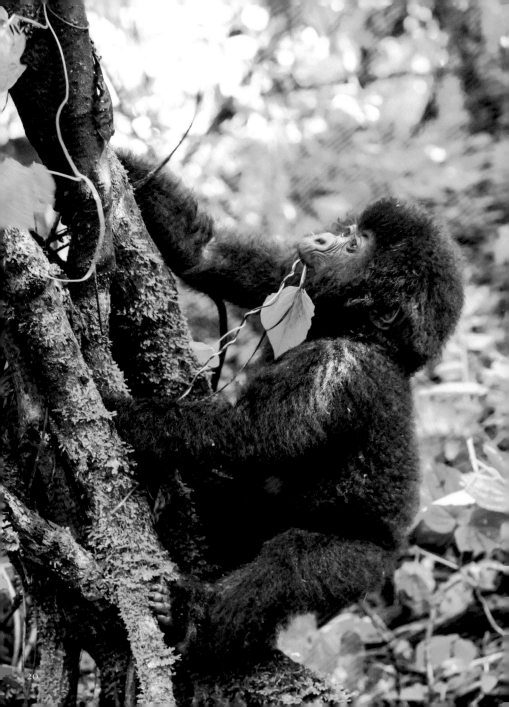

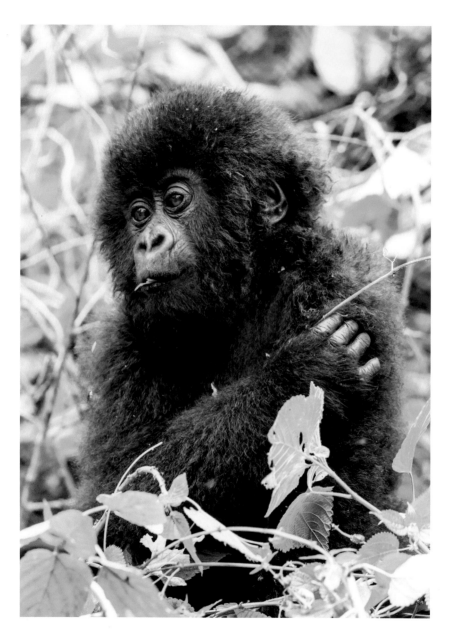

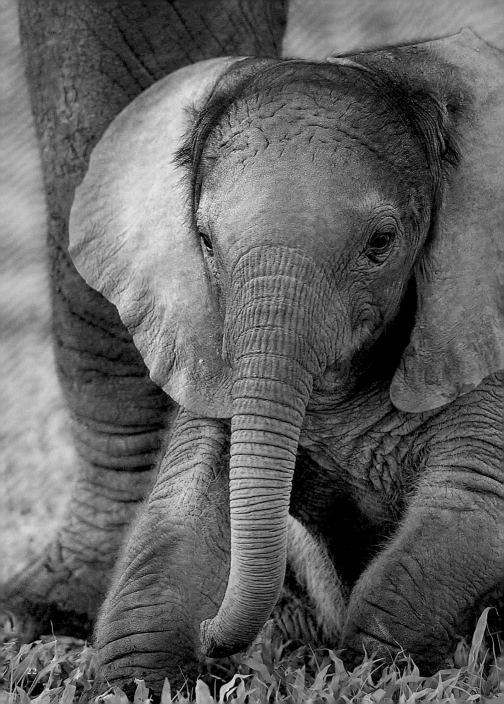

23

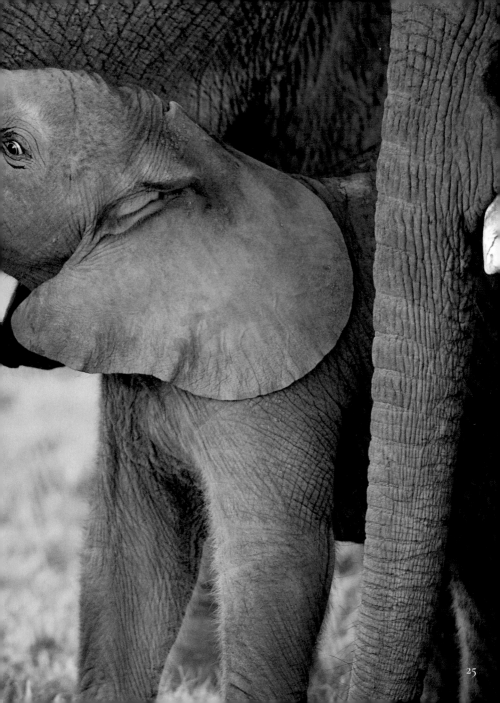

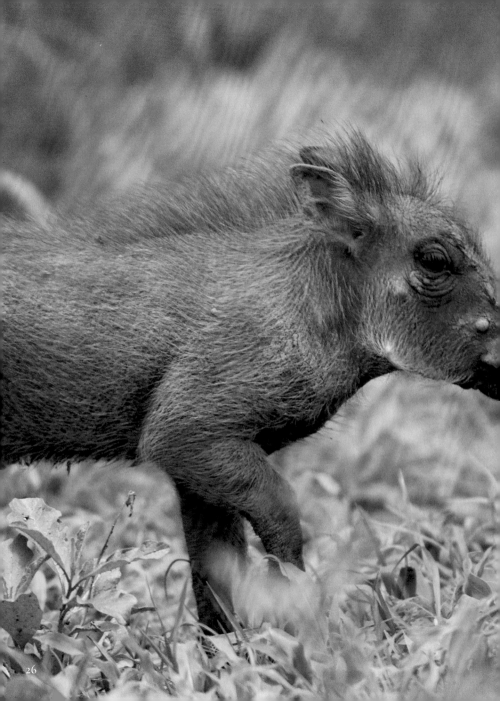

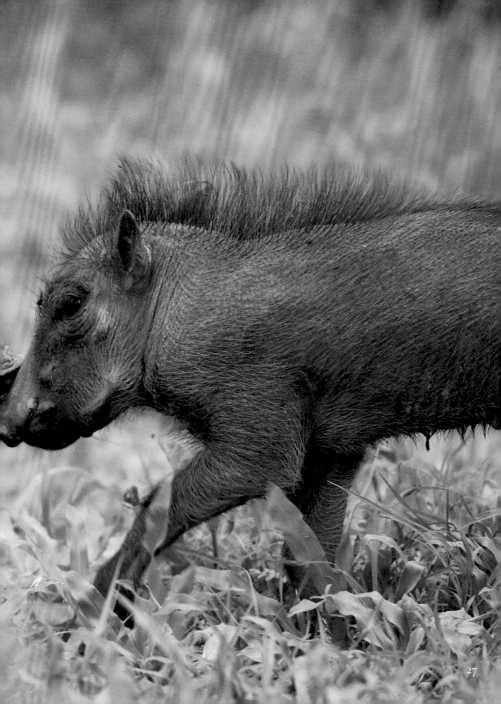

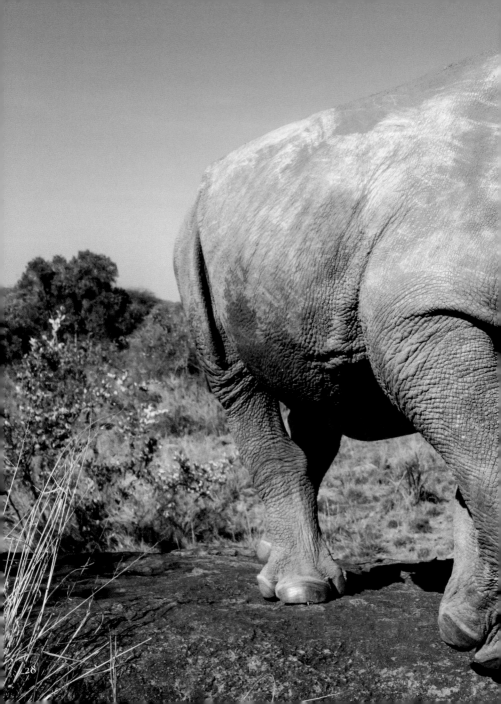

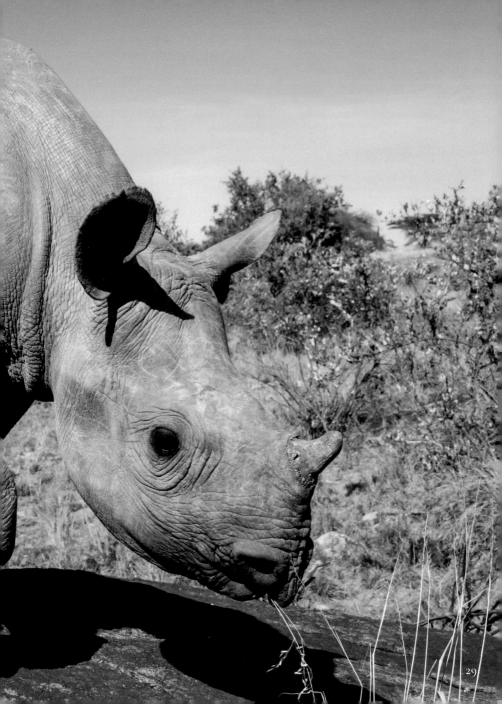

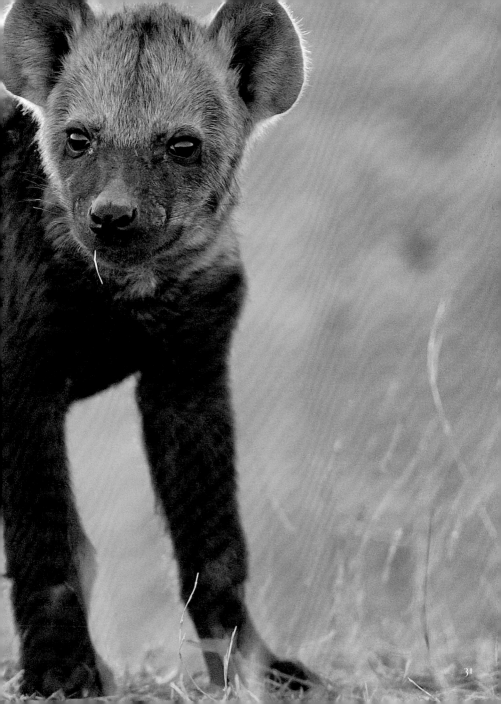

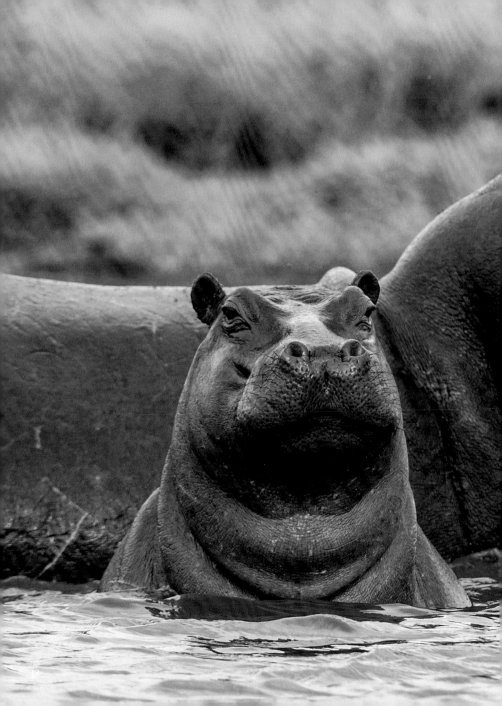

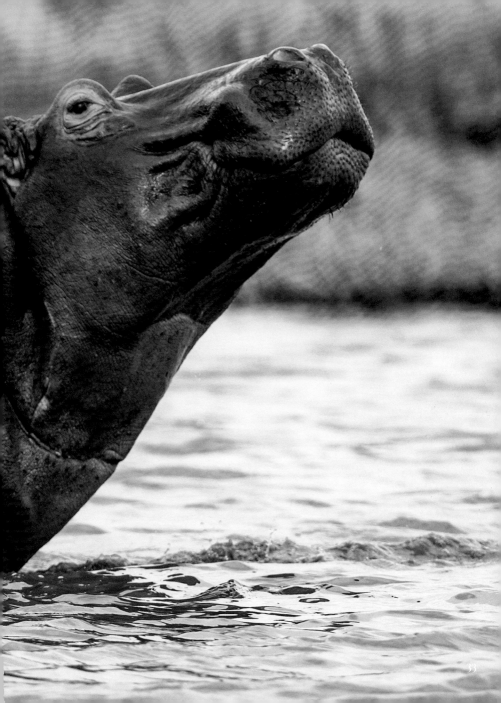

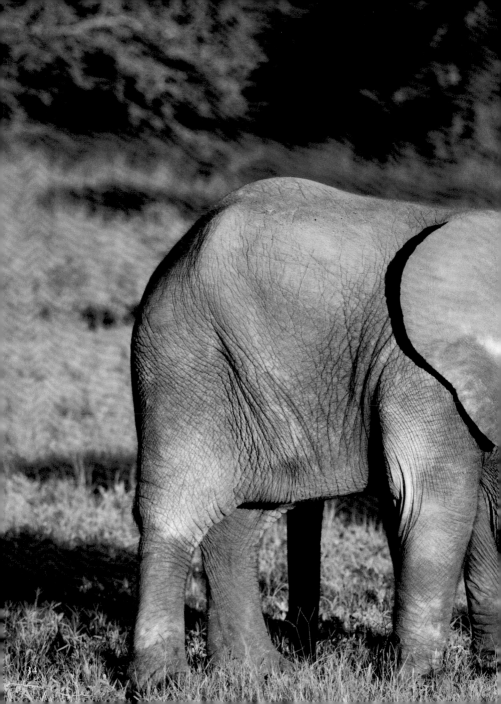

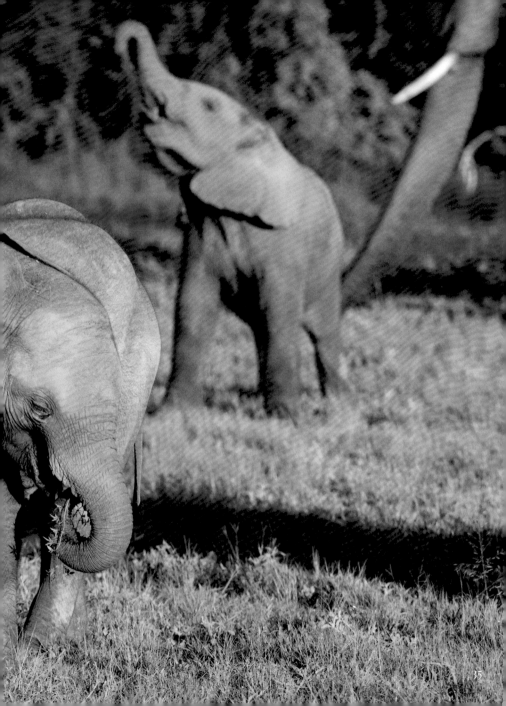

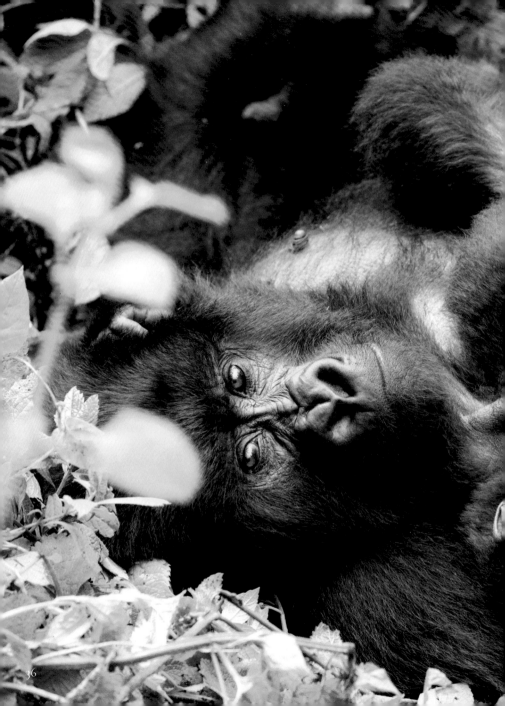

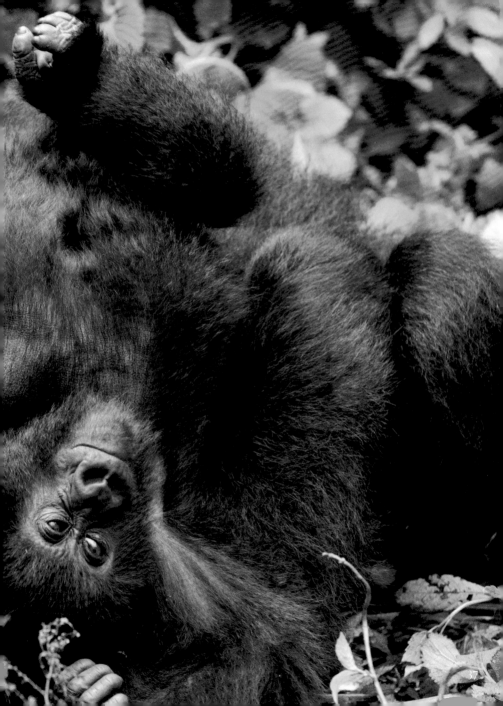

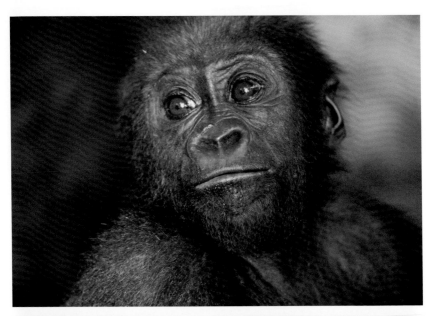

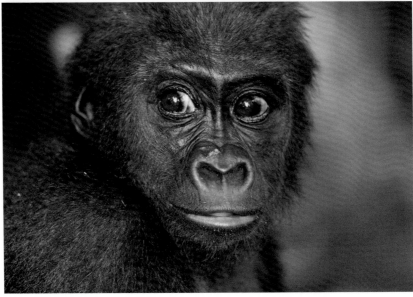

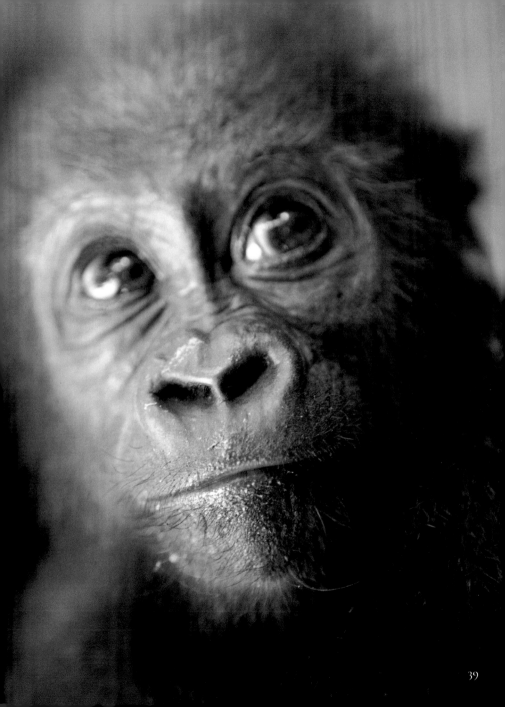

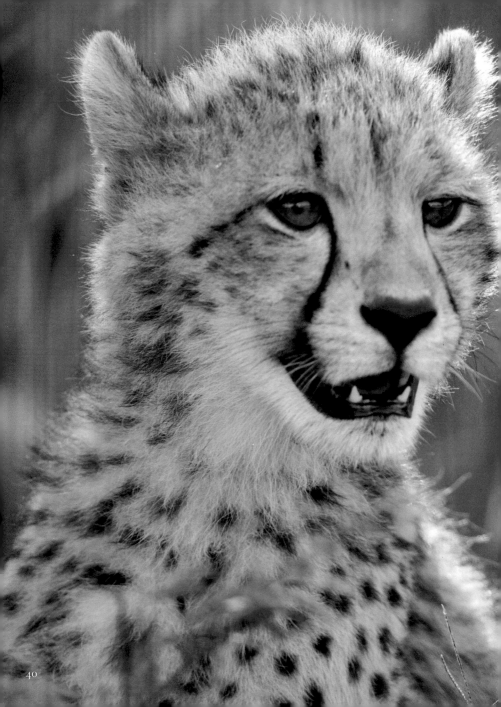

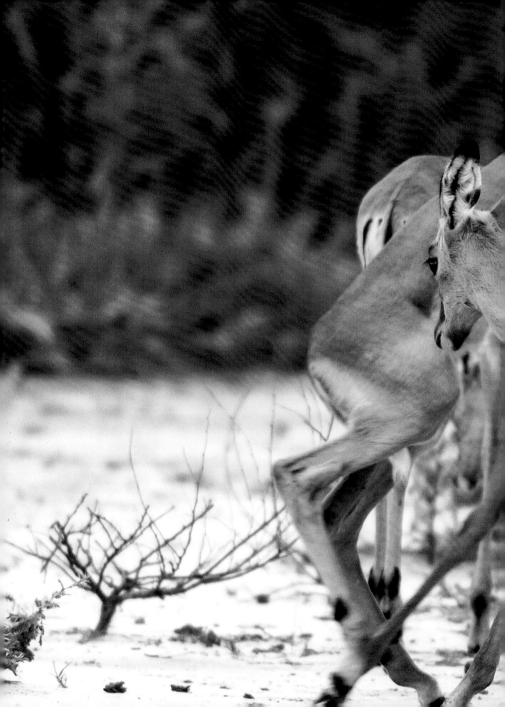

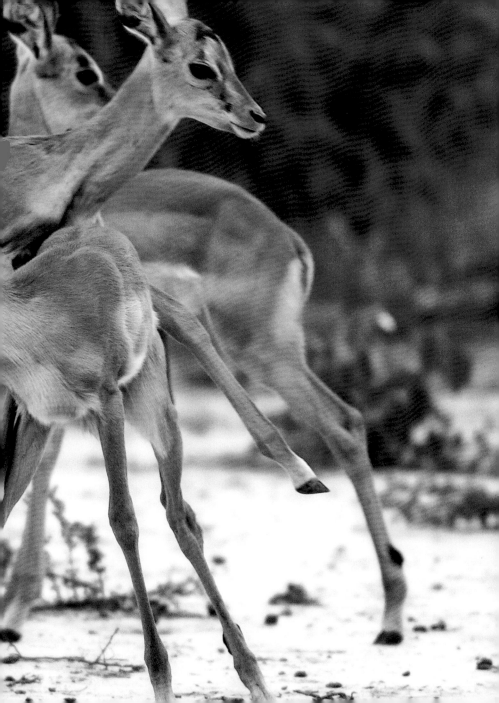

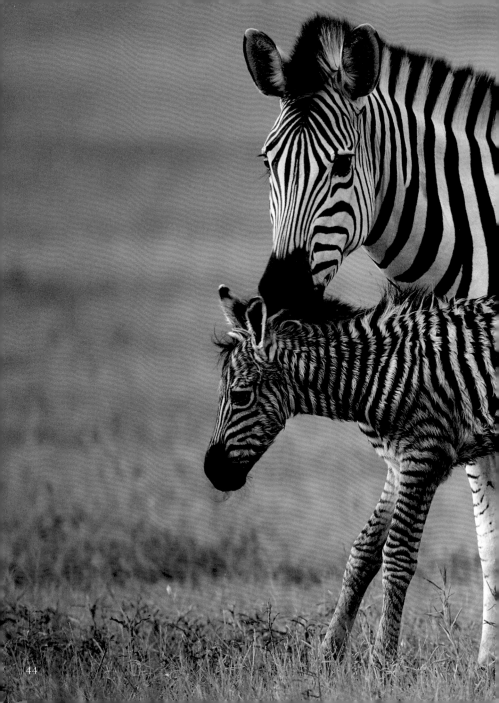

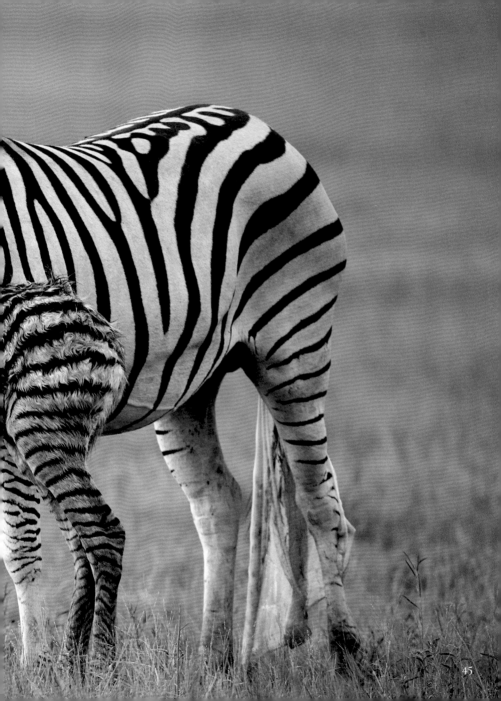

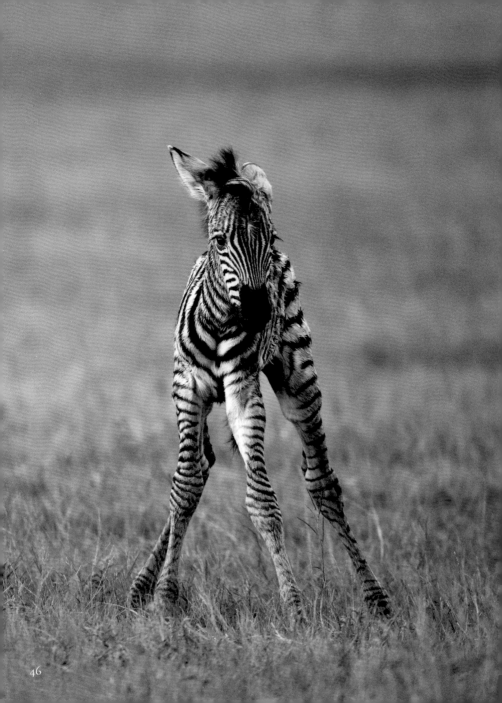

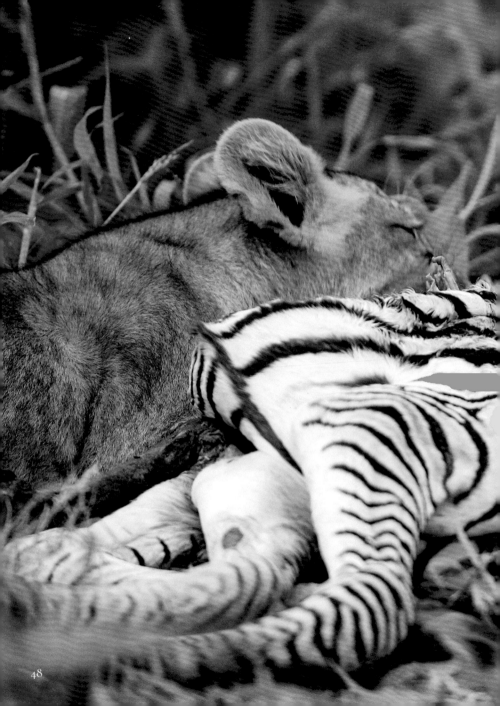

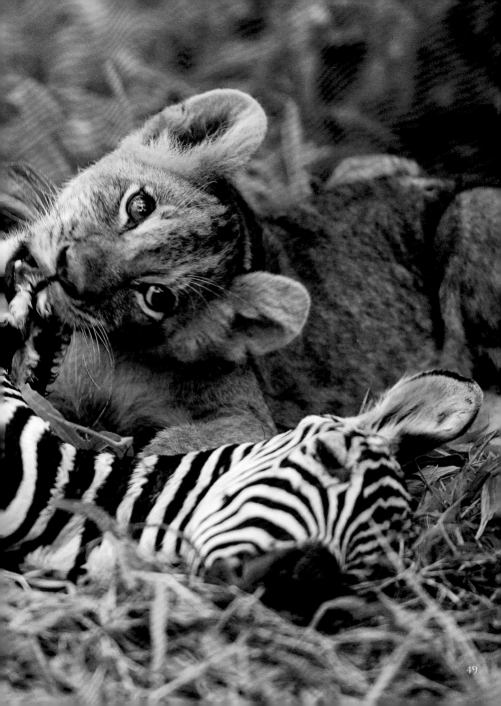

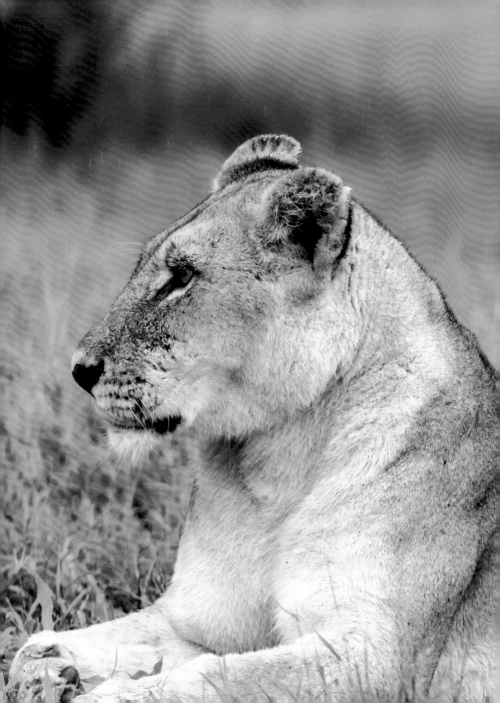

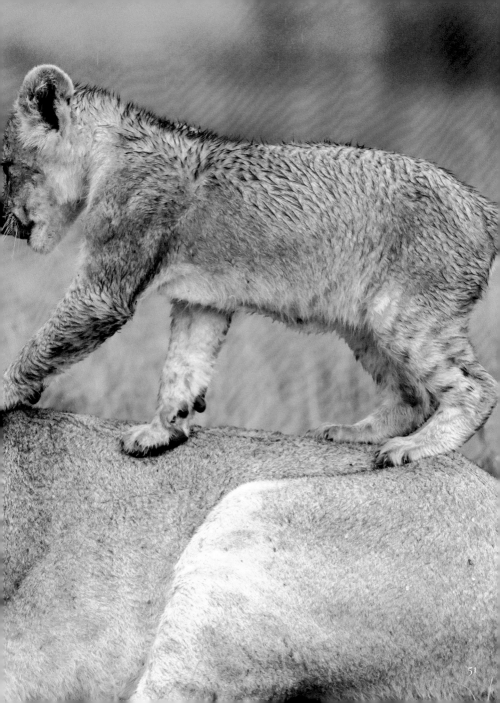

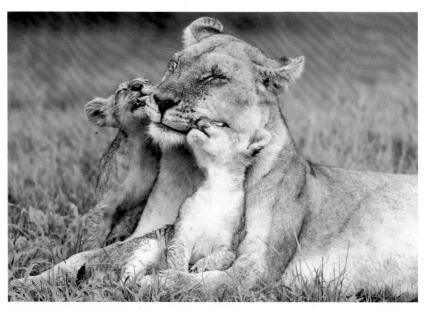

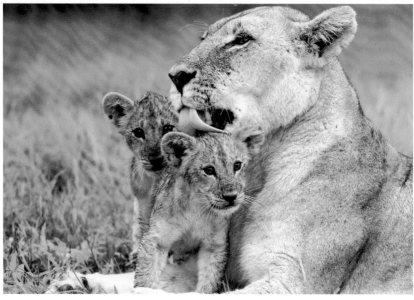

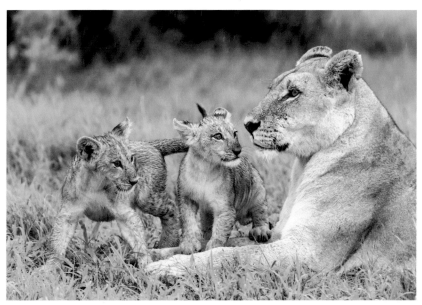

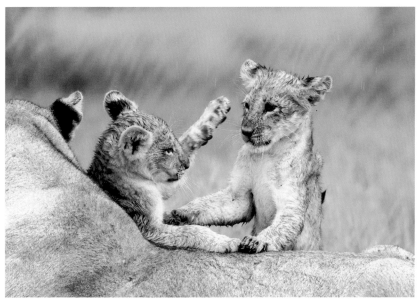

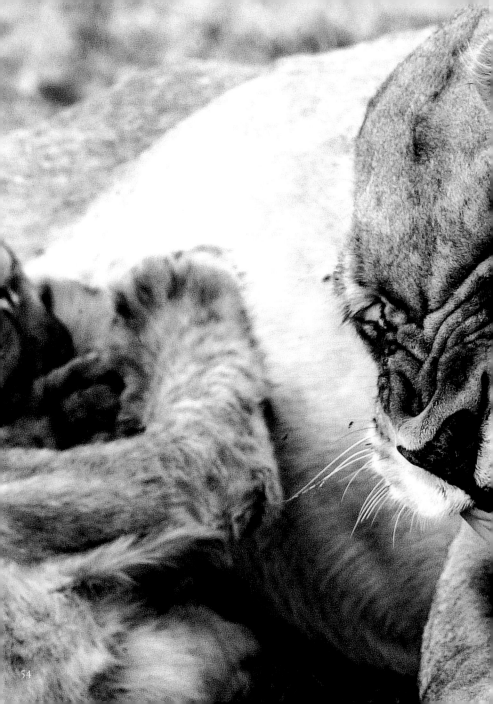

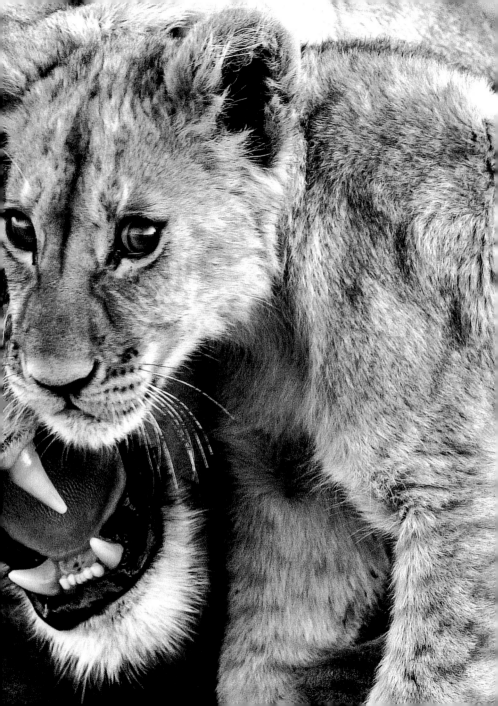

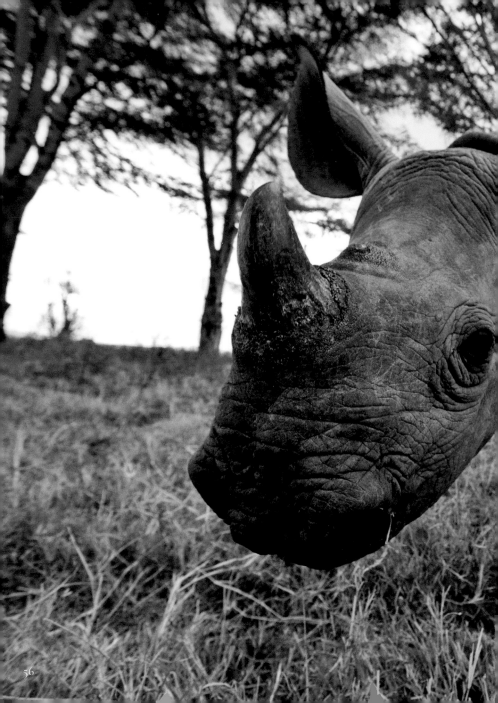

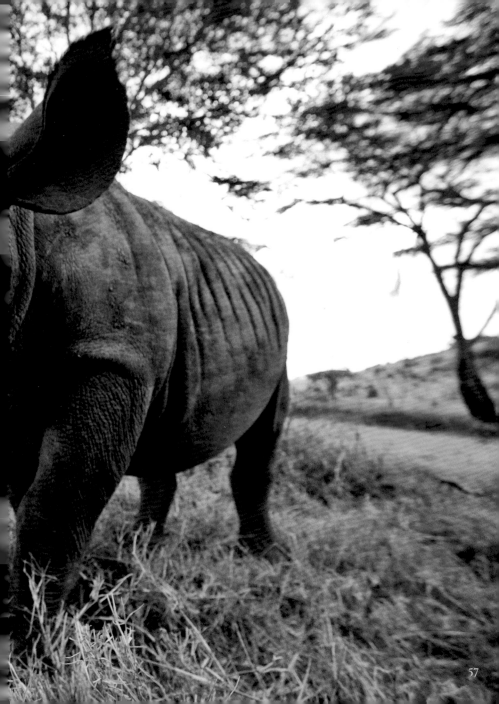

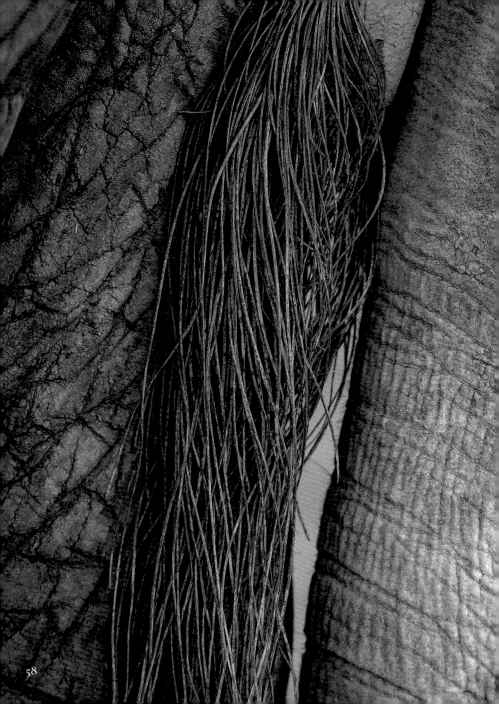

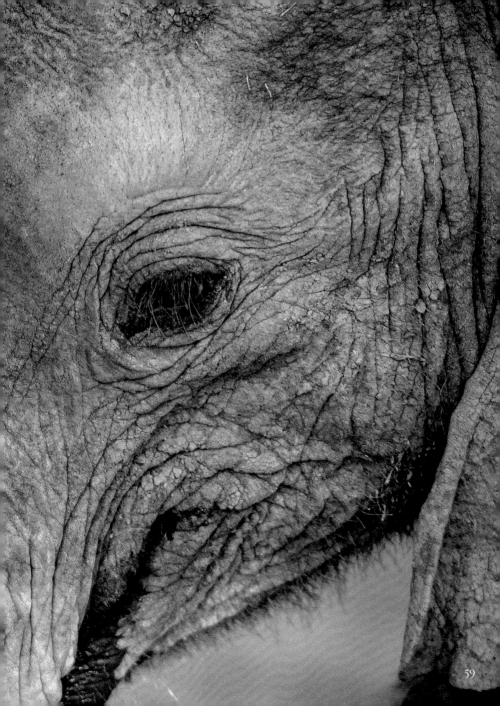

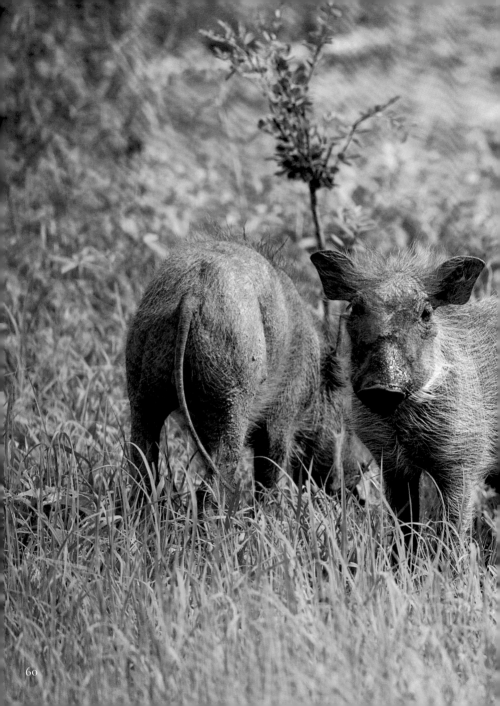

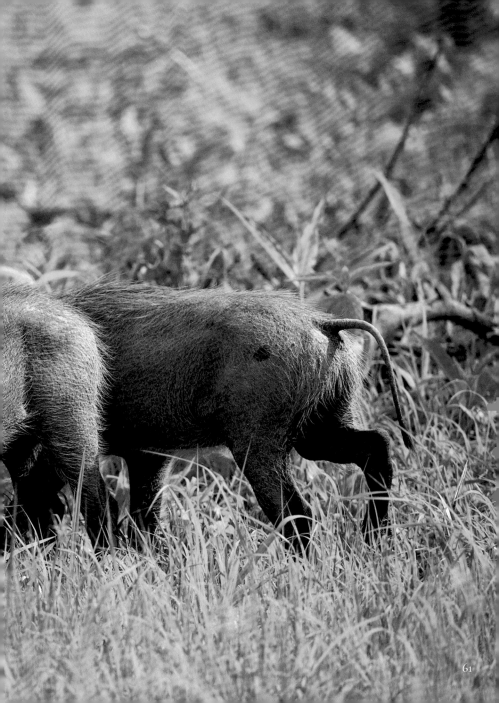

61

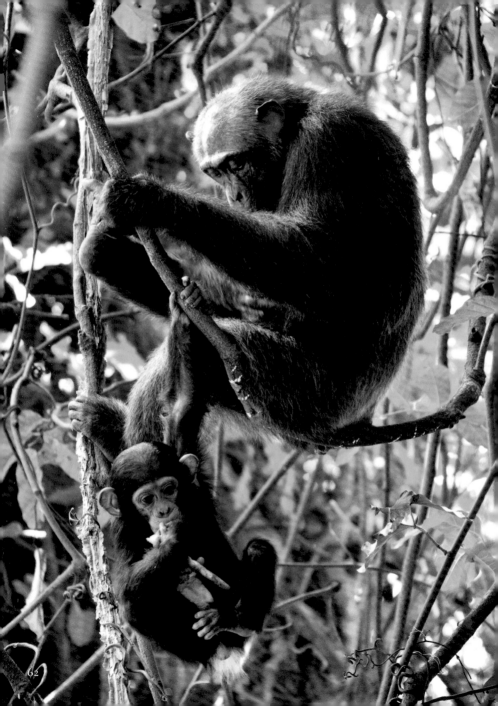

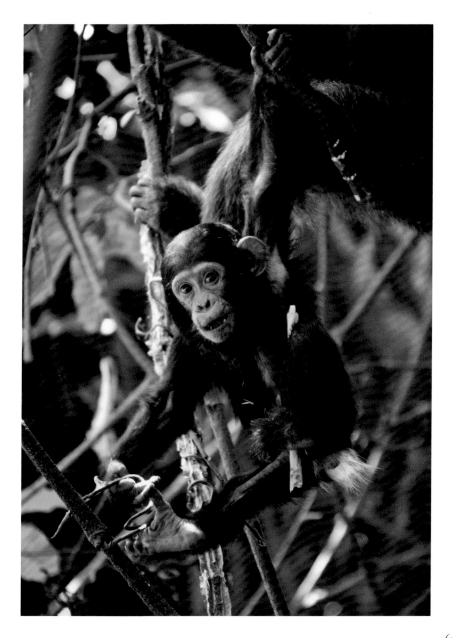

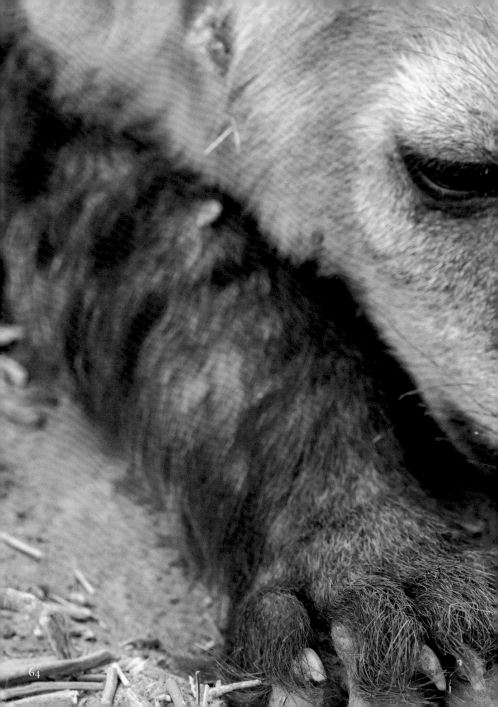

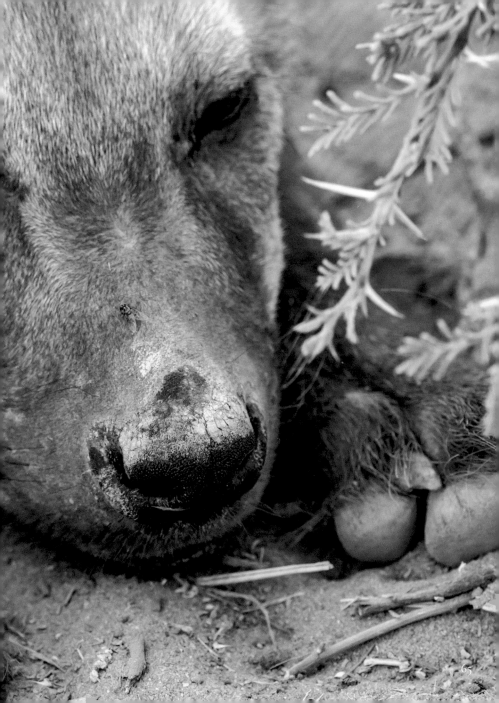

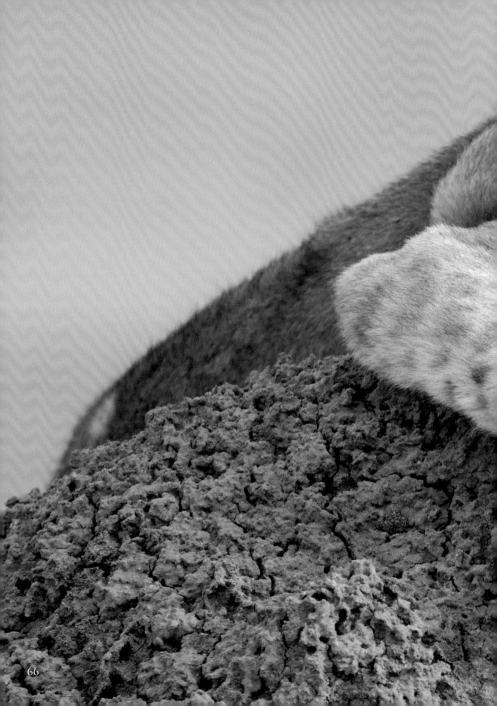

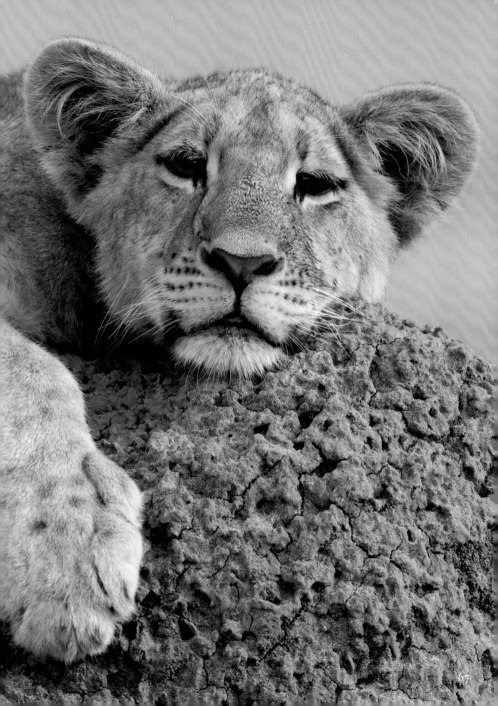

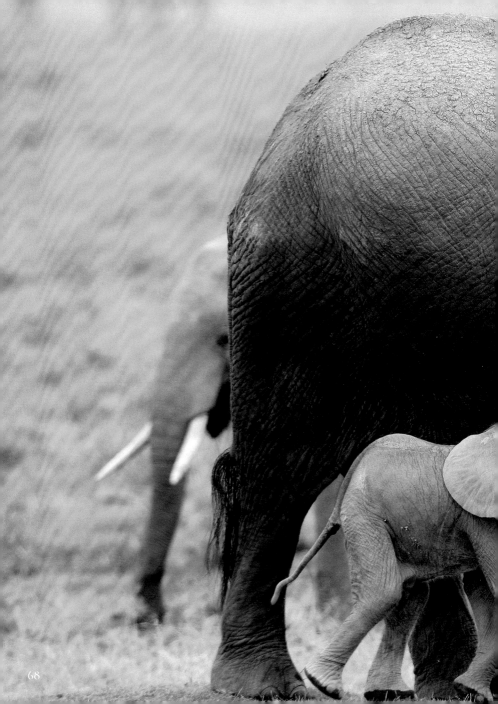

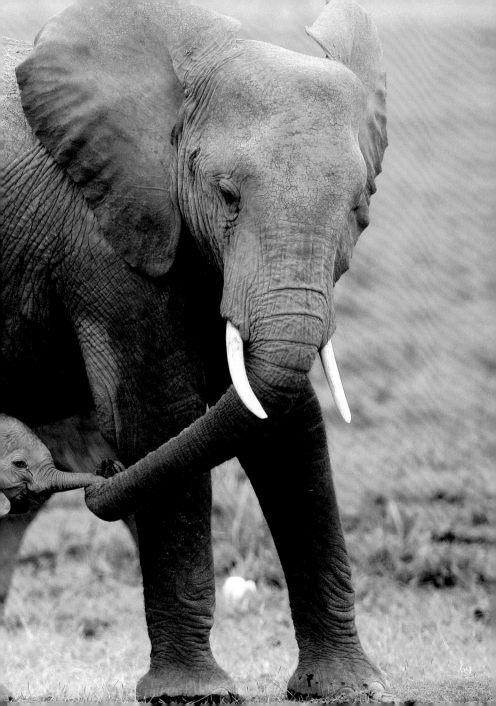

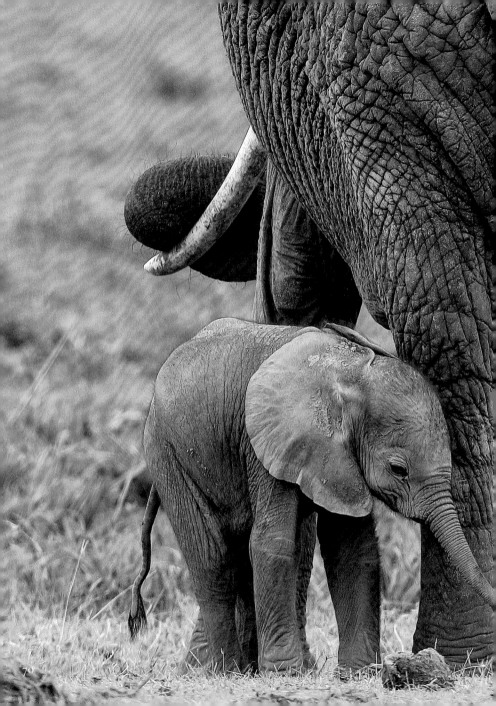

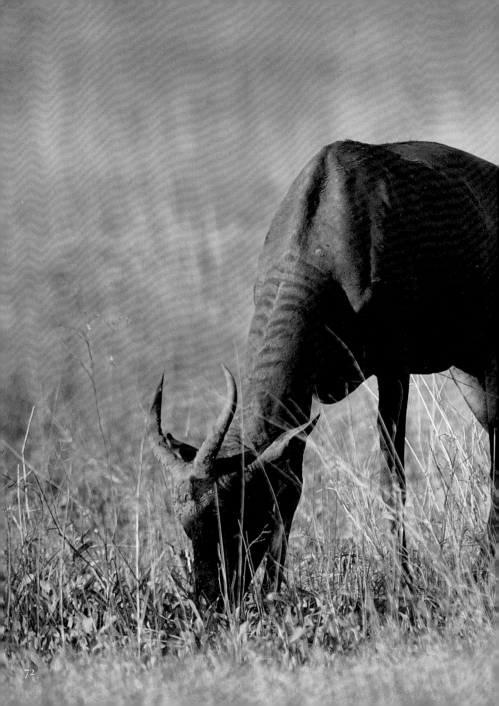

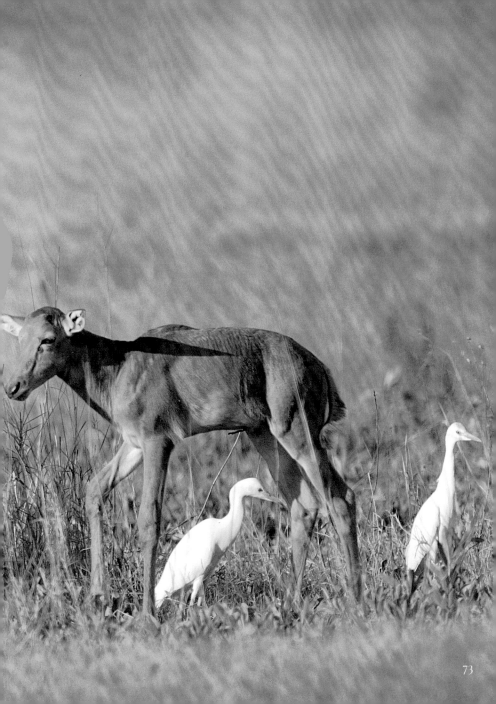

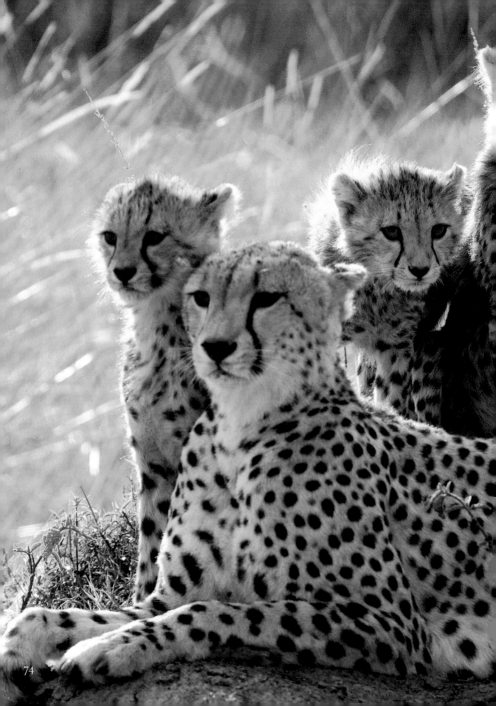

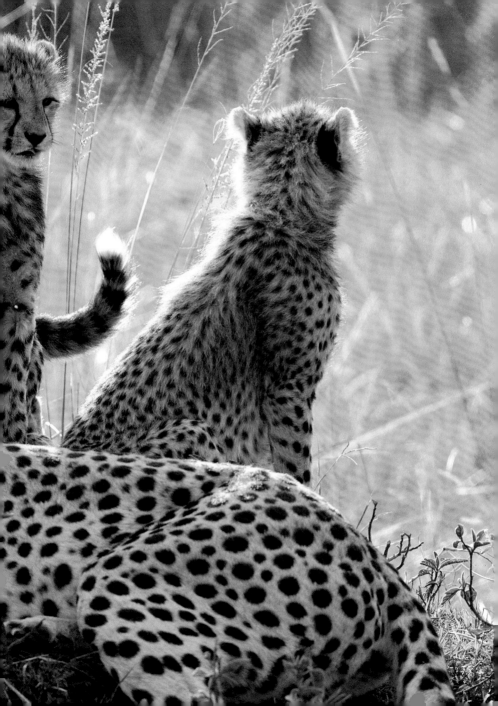

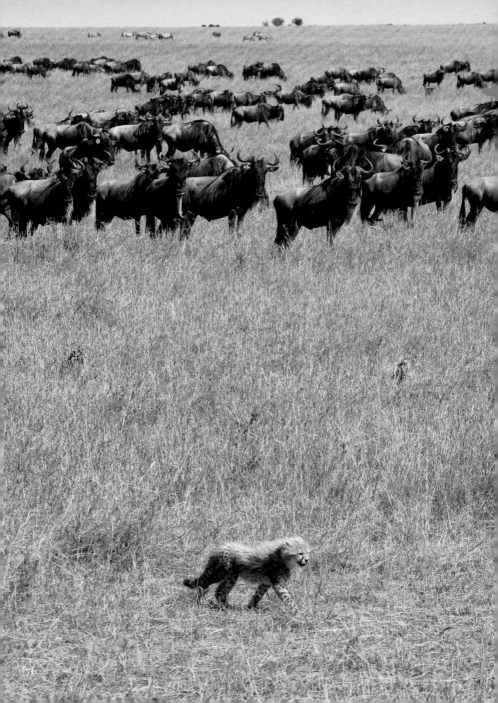

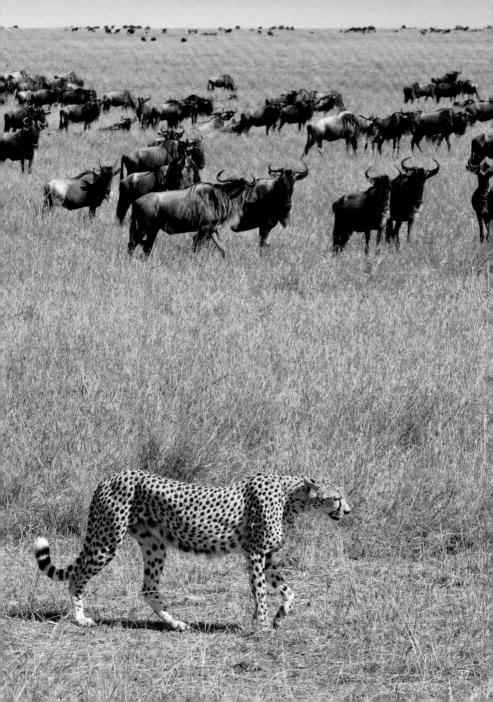

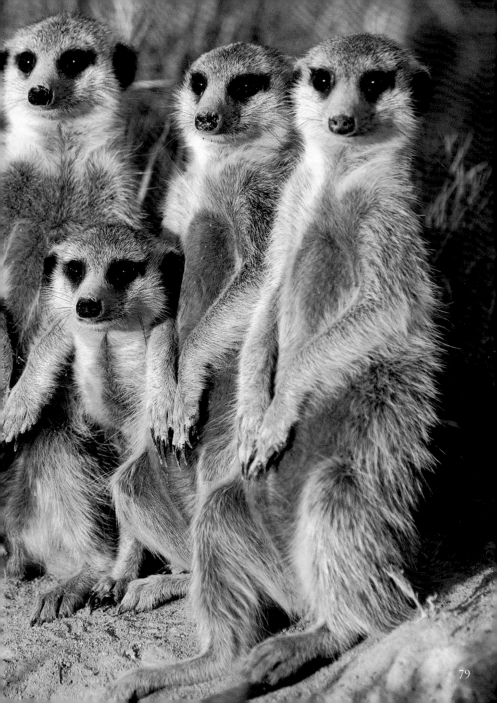

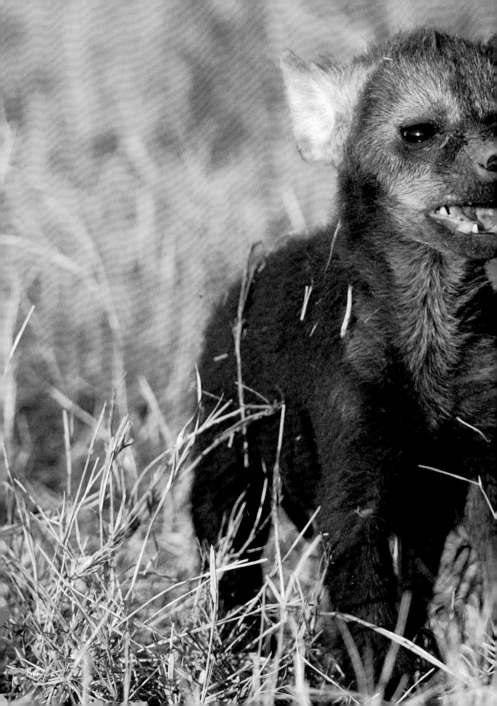

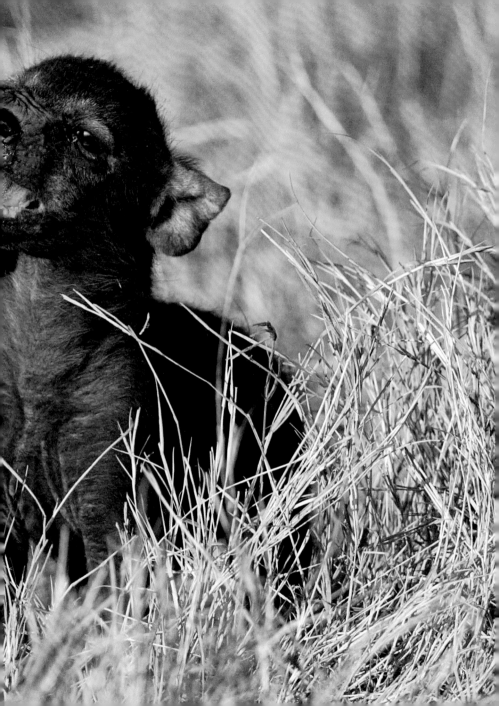

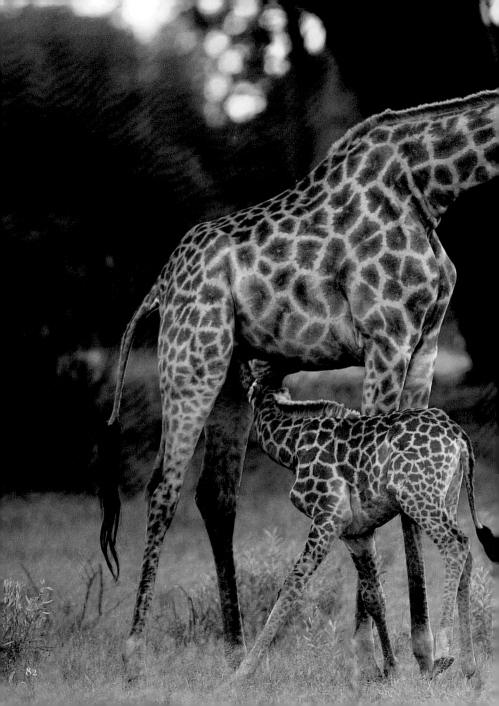

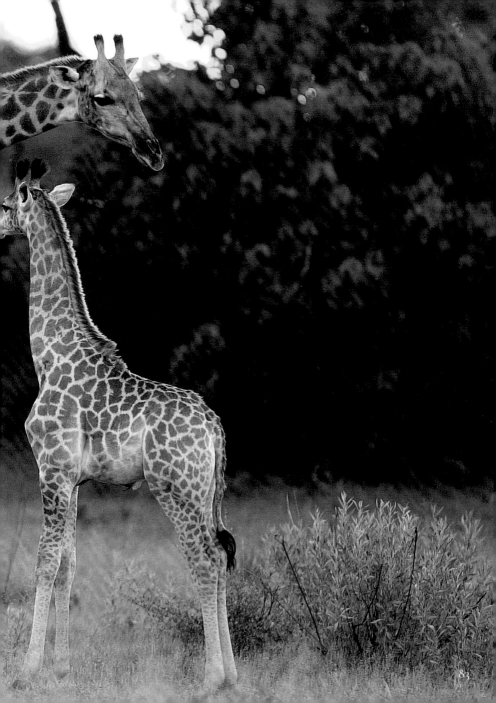

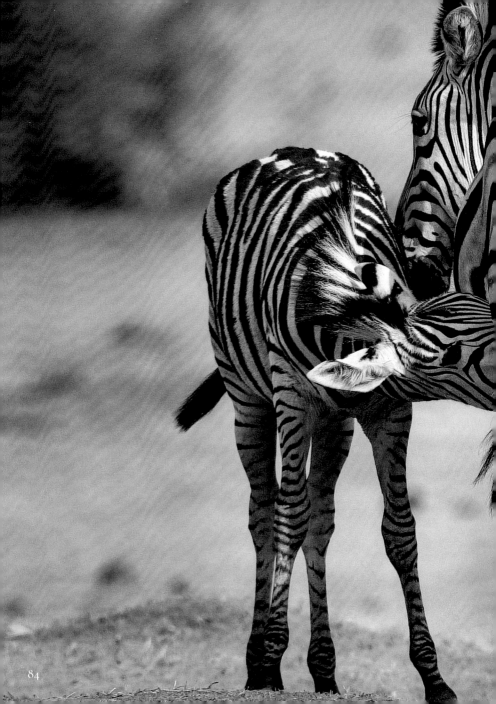

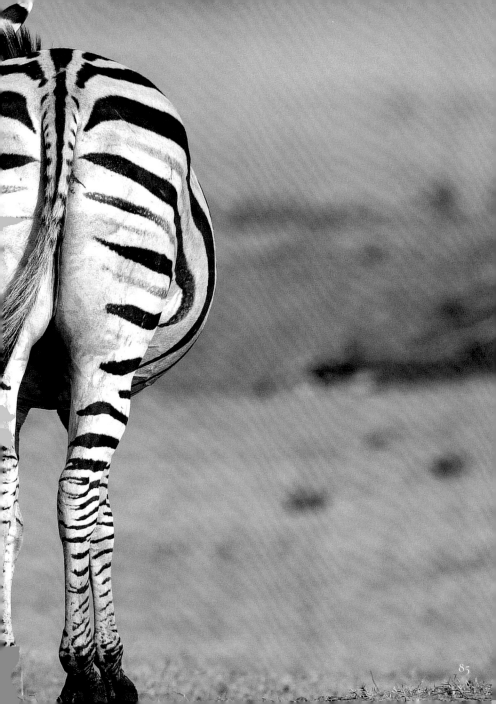

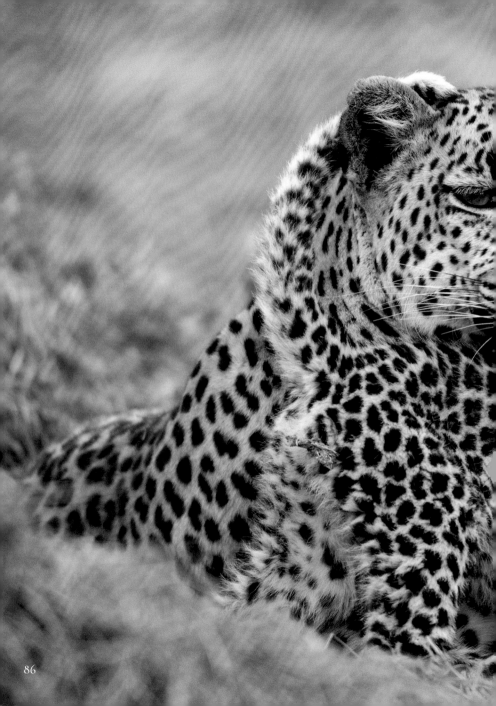

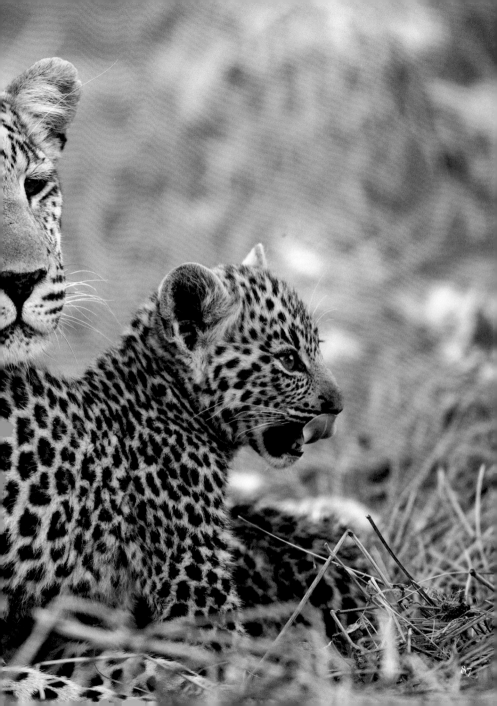

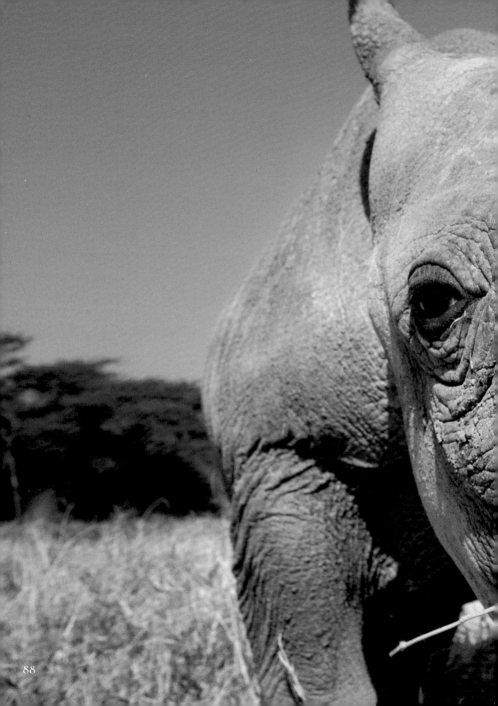

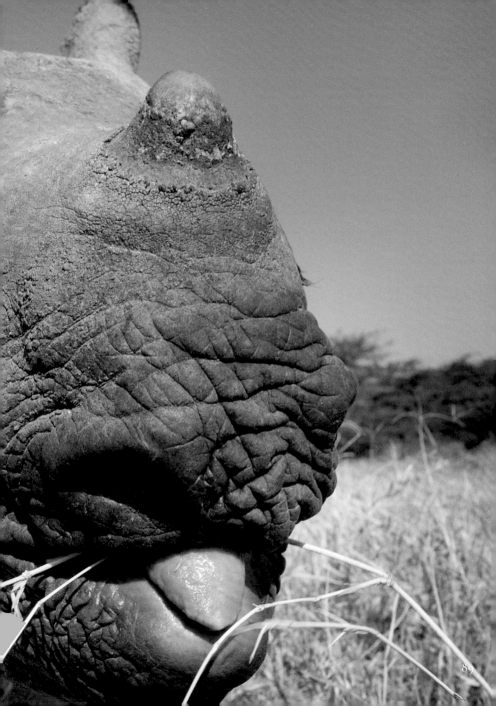

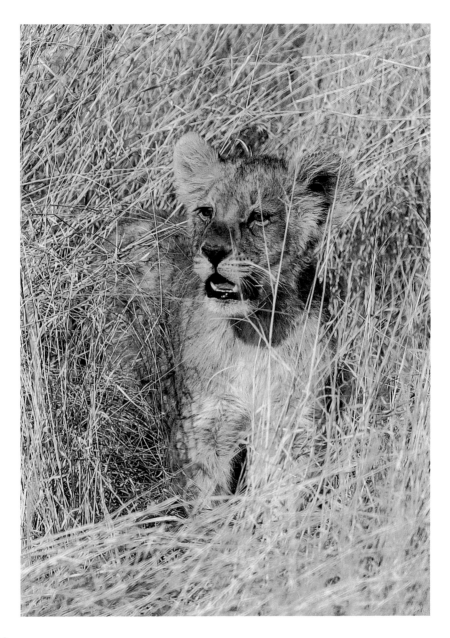

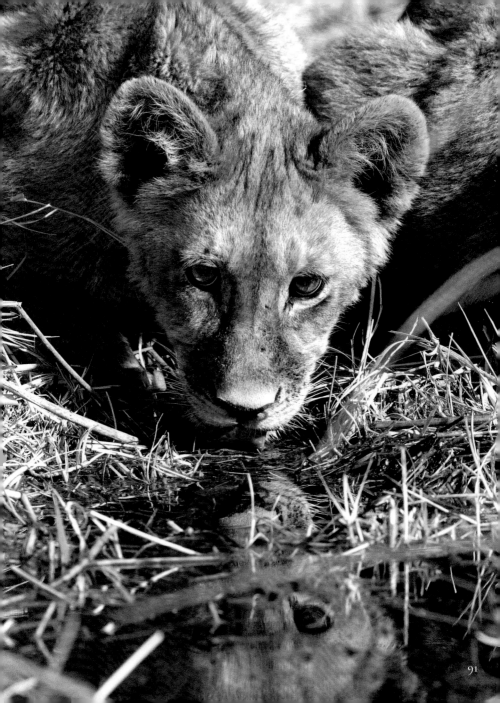

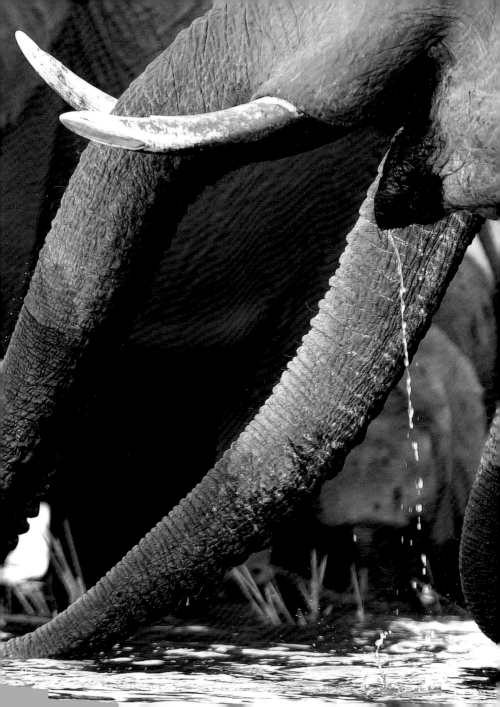

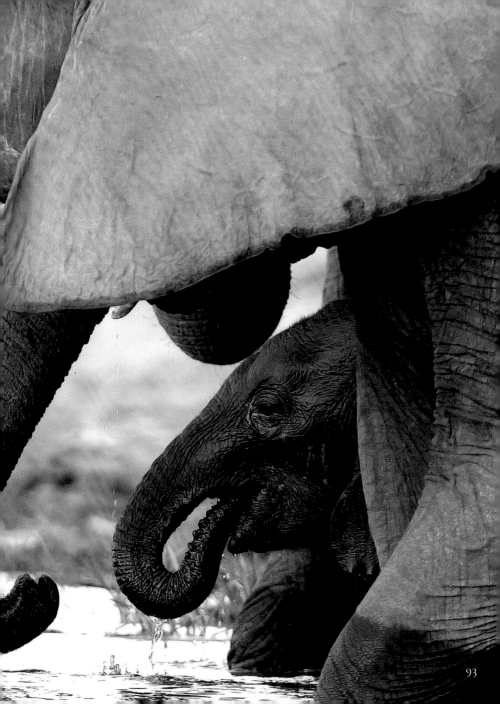

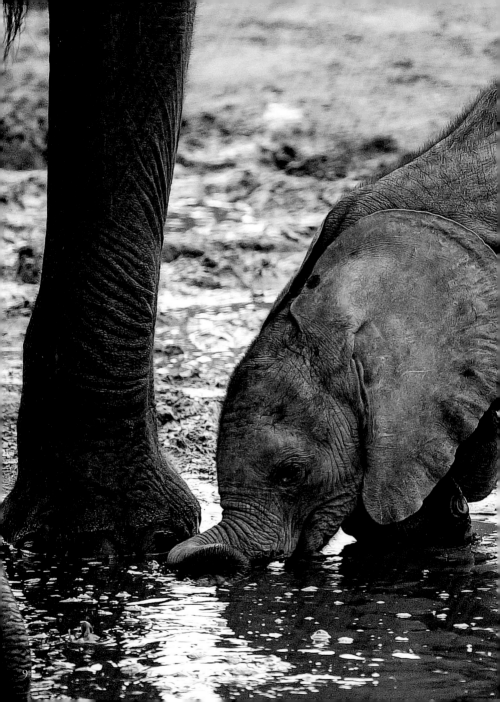

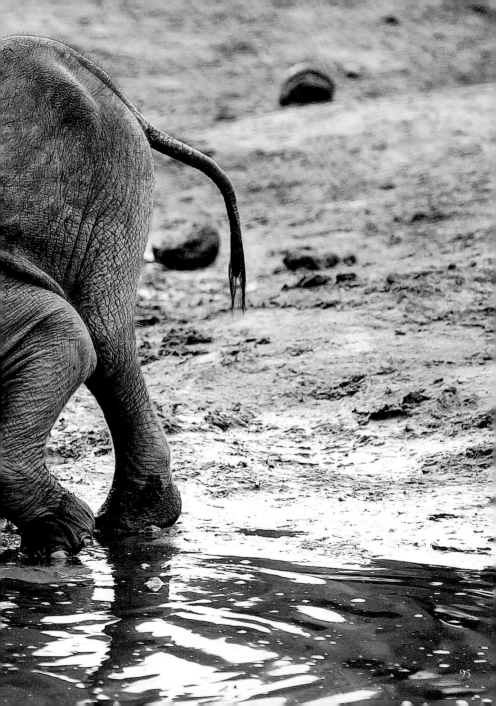

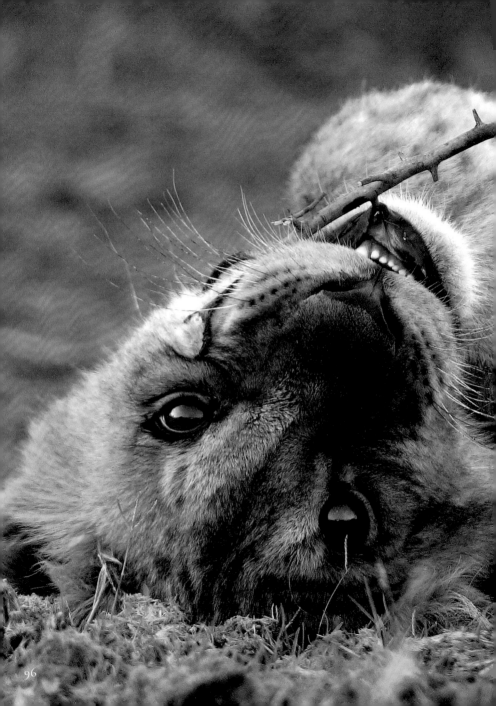

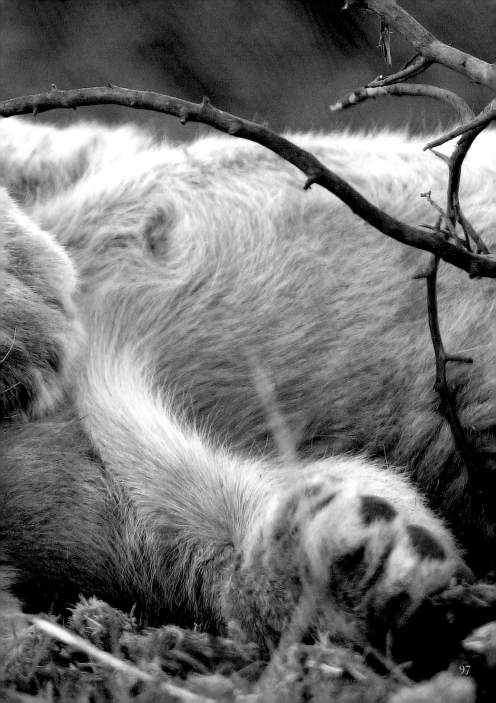

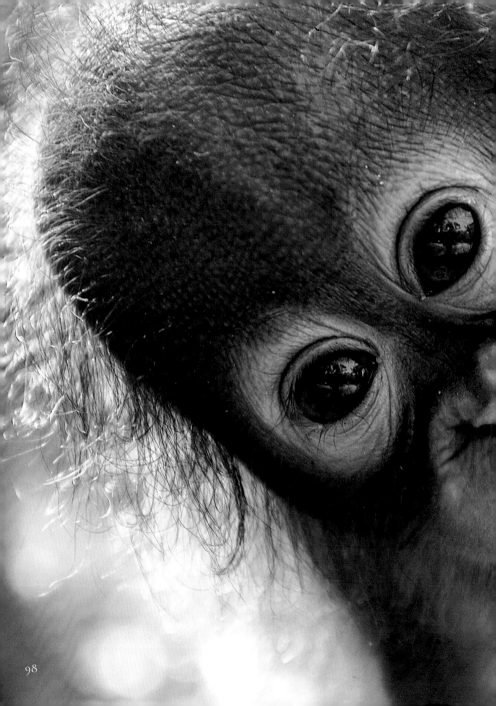

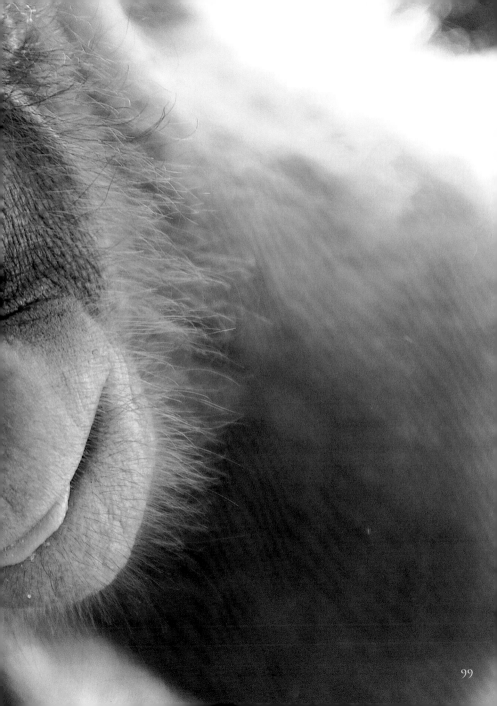

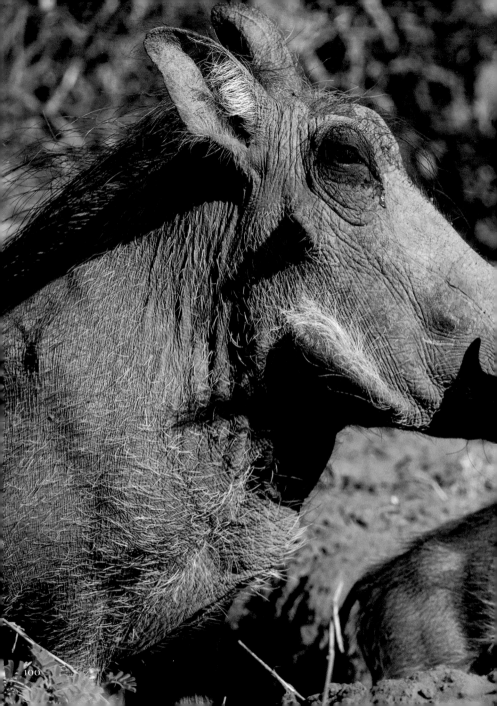

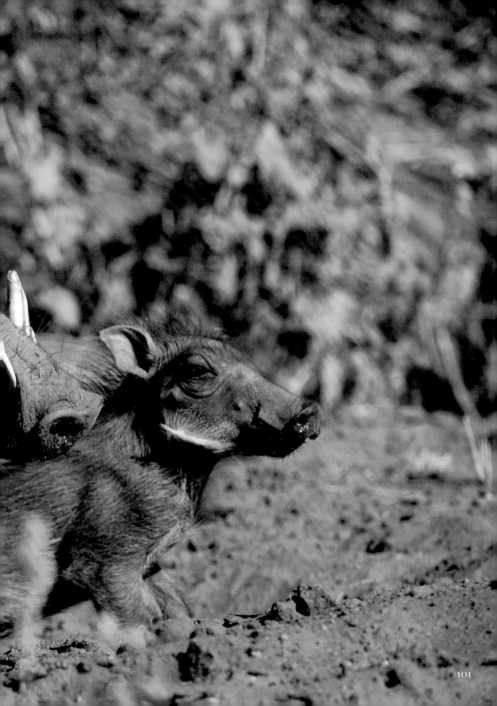

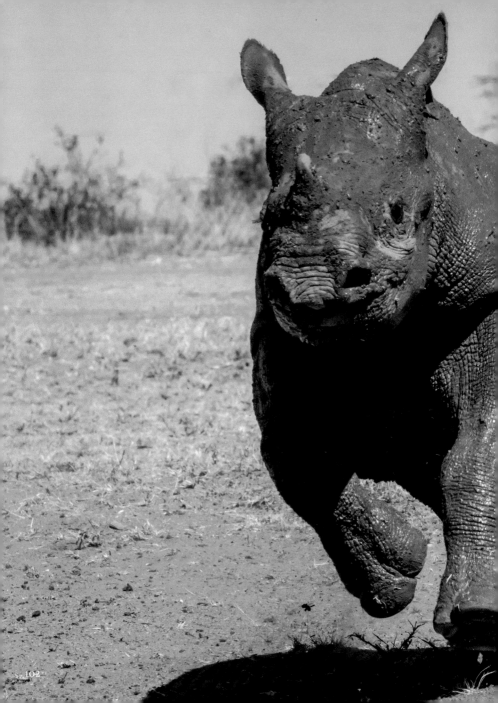

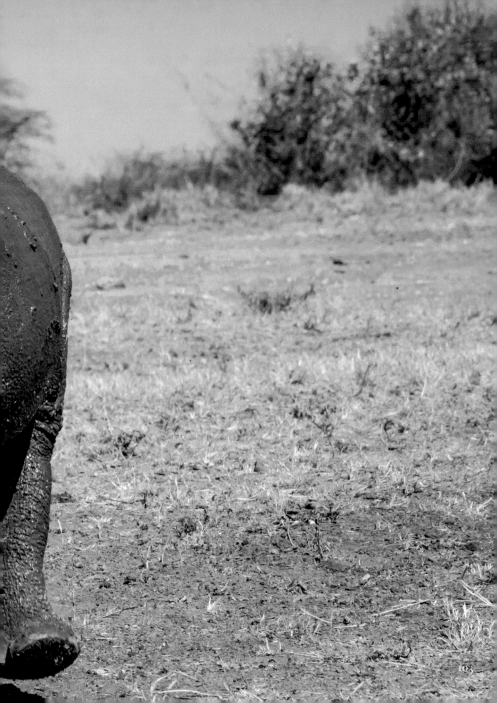

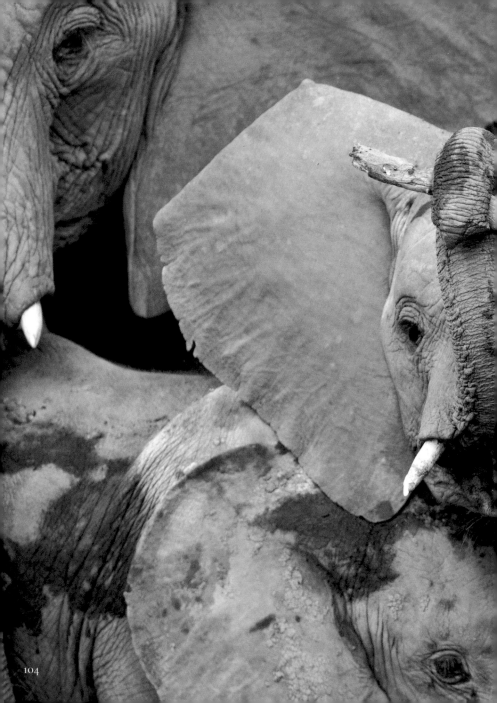

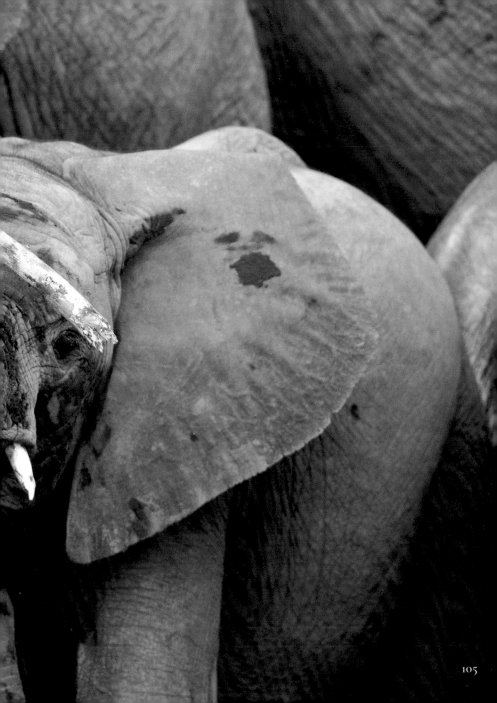

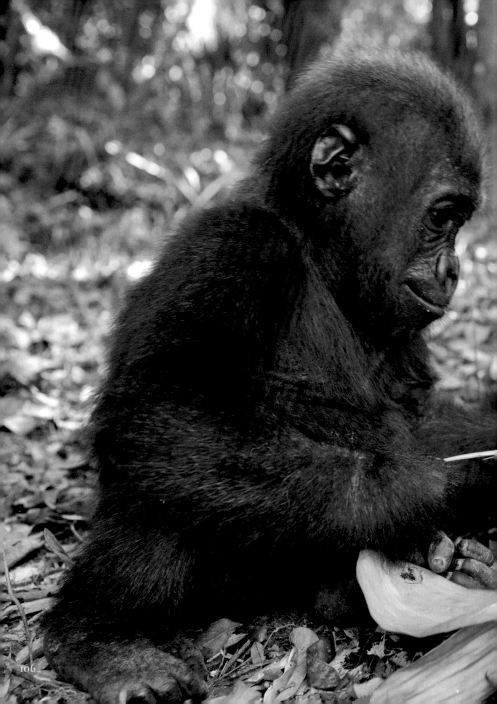

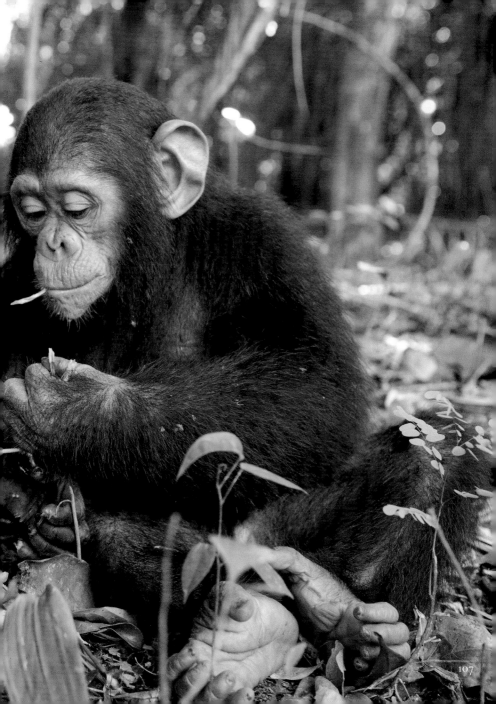

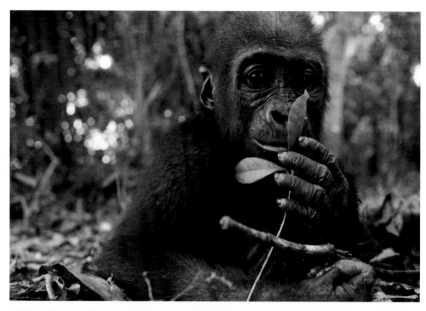

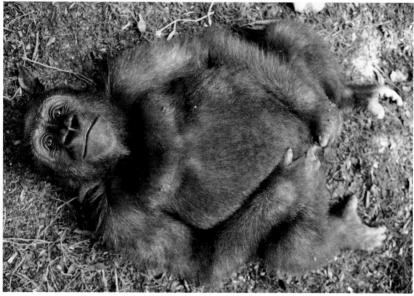

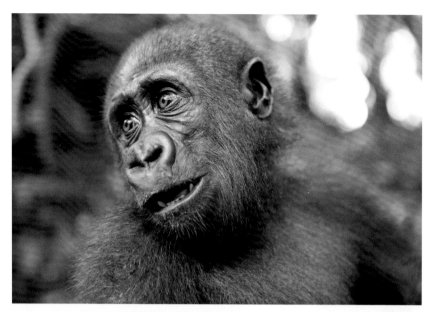

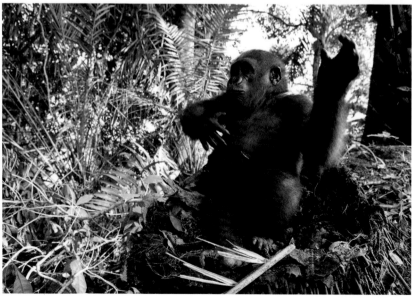

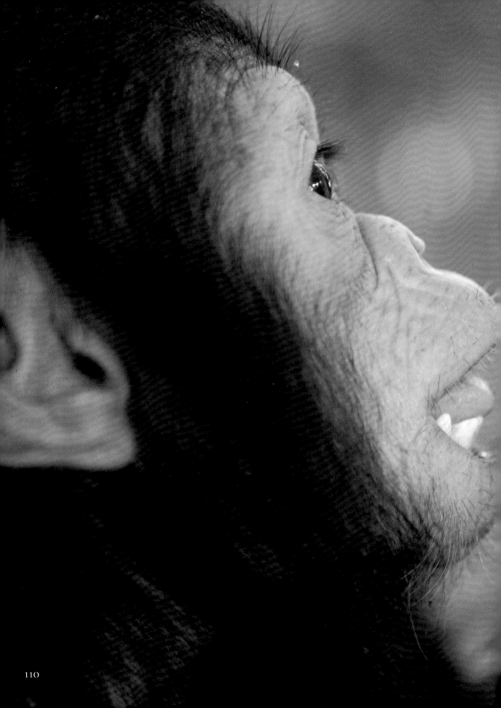

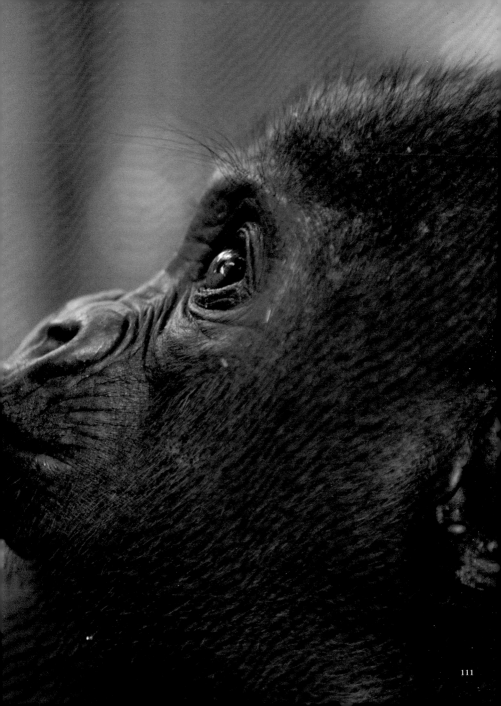

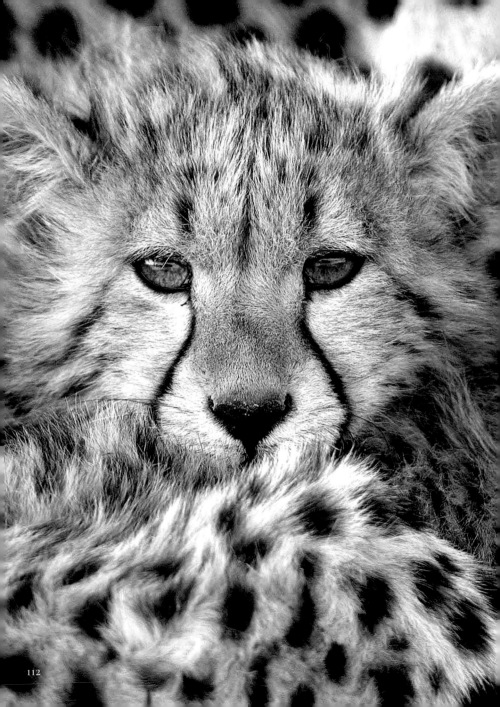

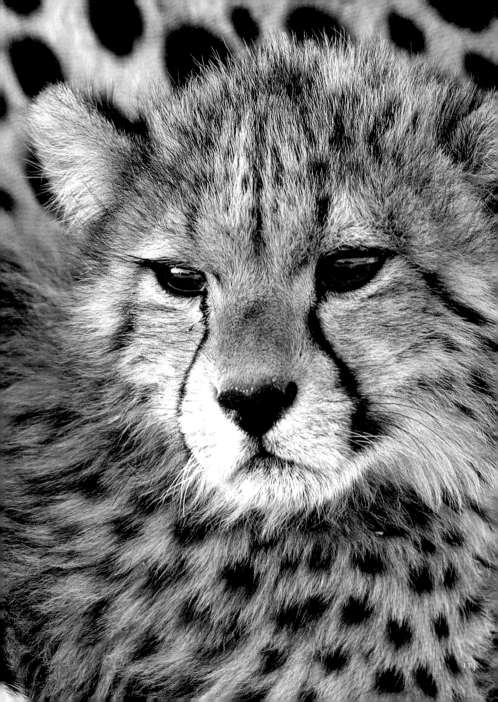

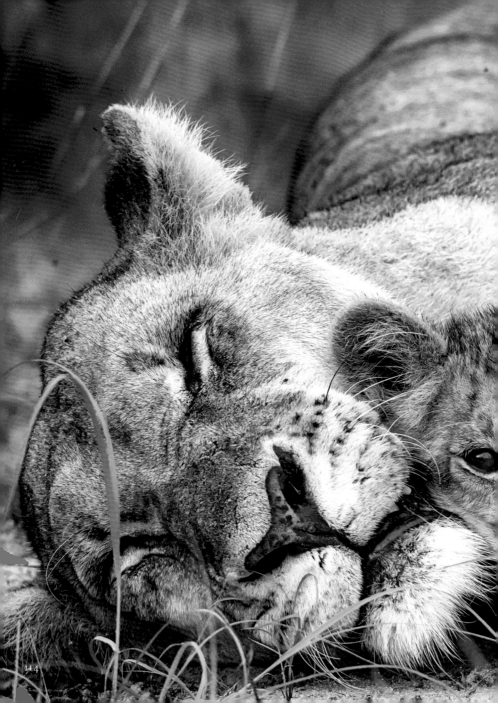

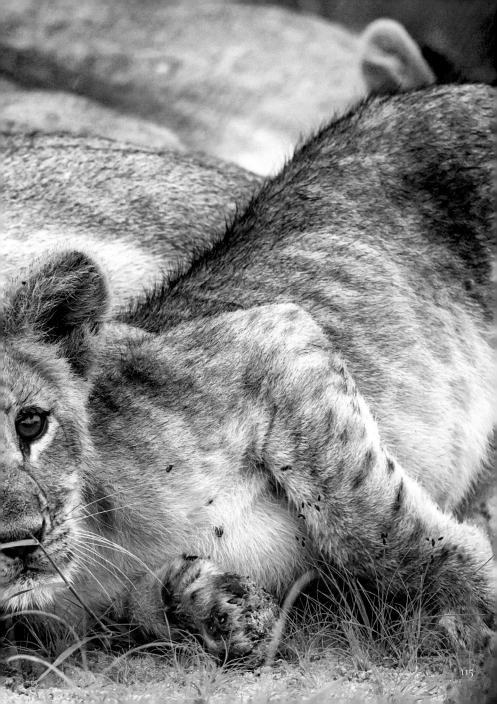

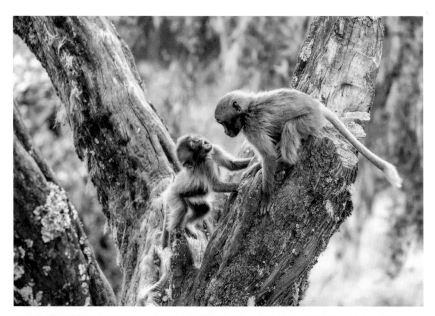

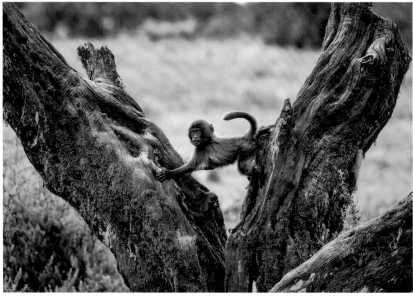

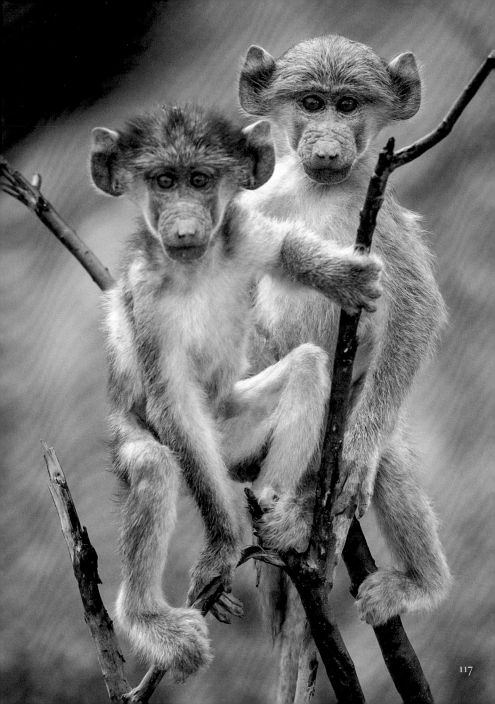

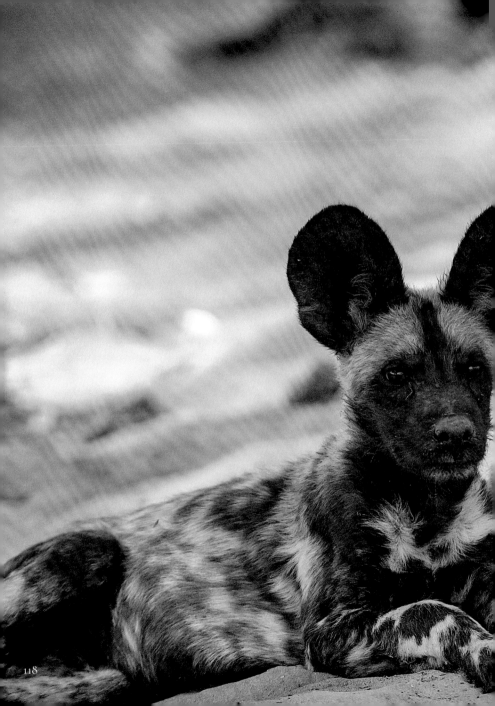

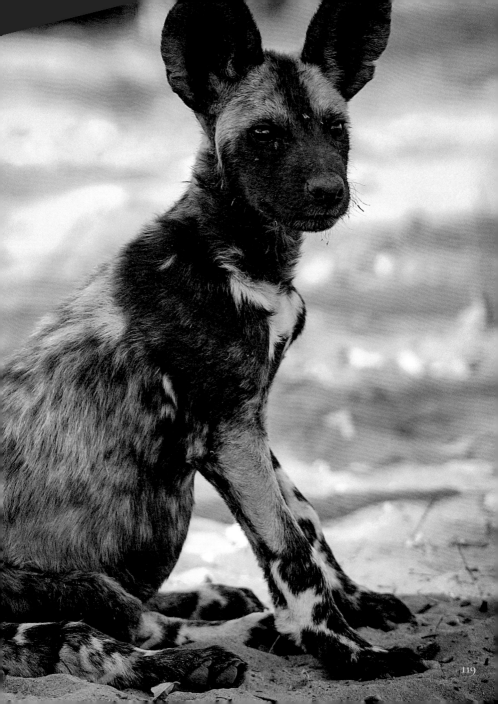

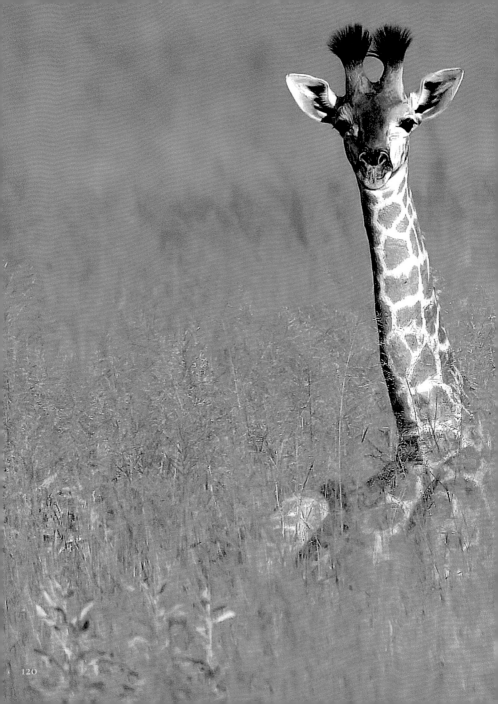

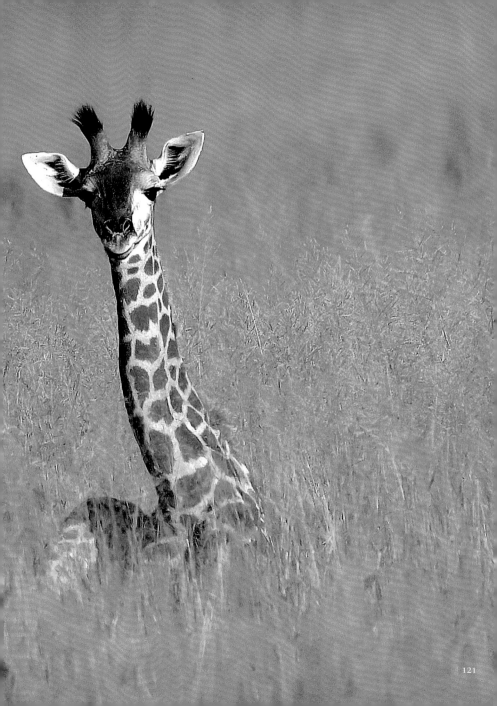

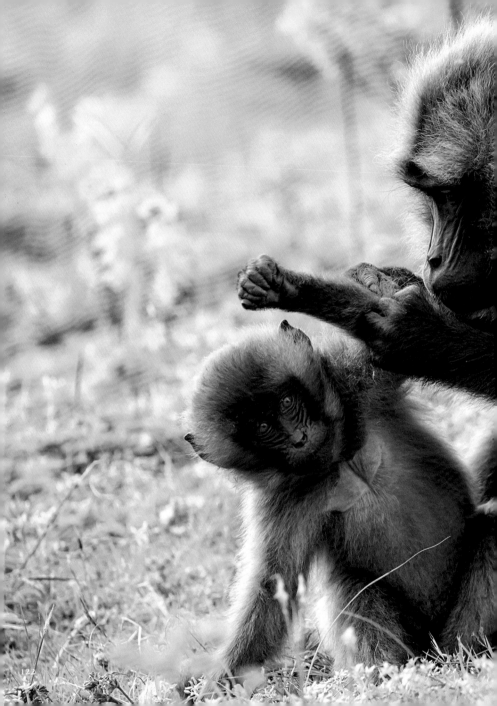

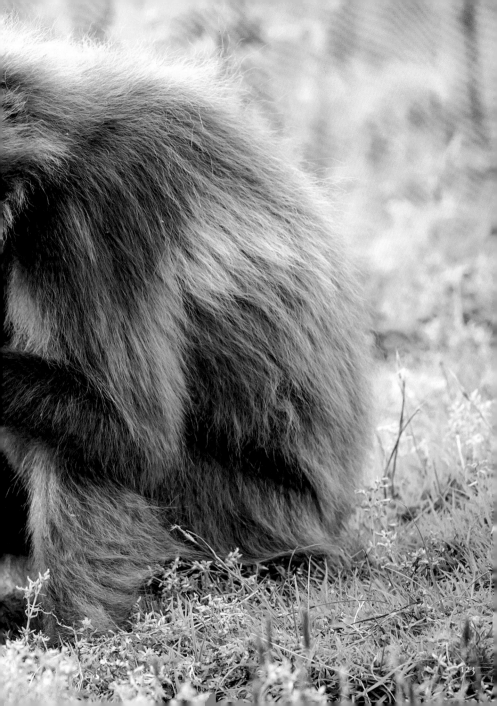

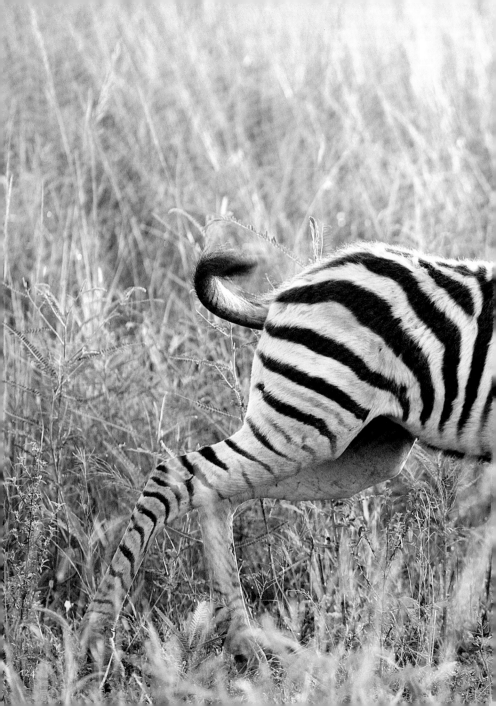

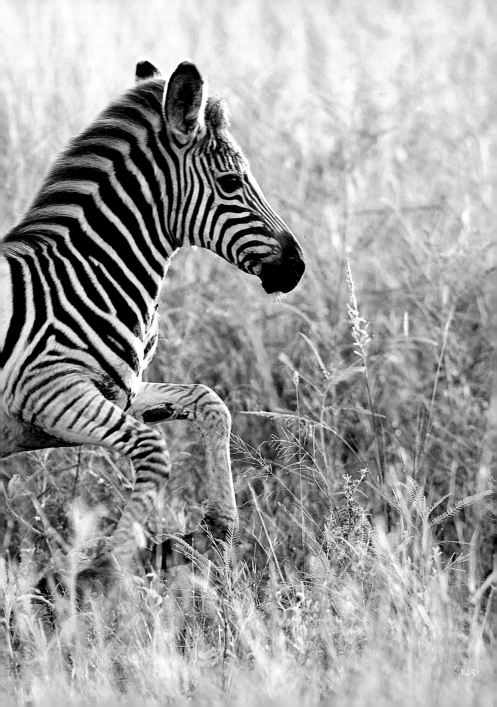

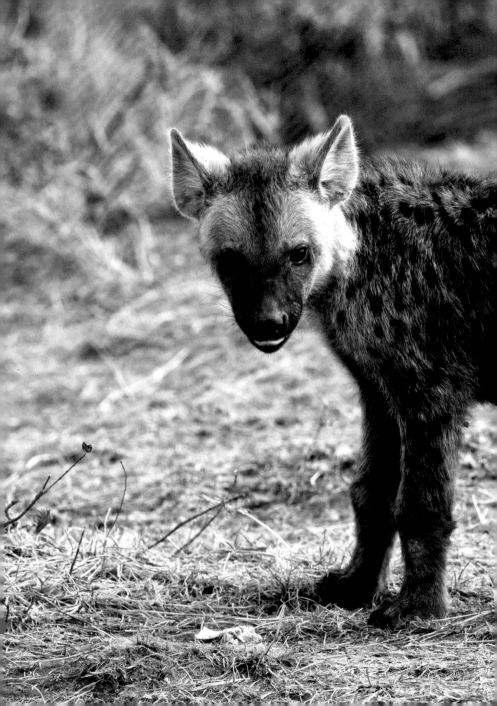

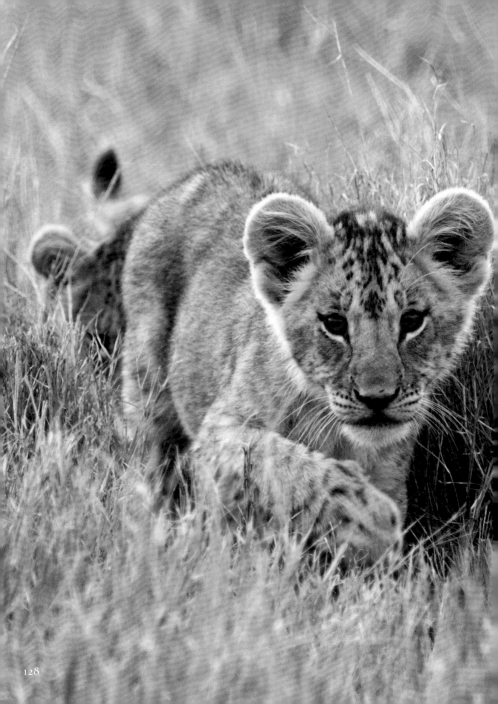

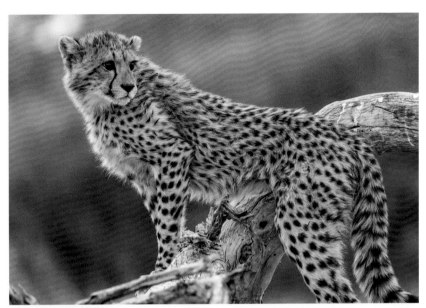

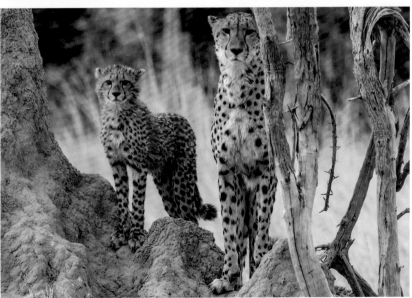

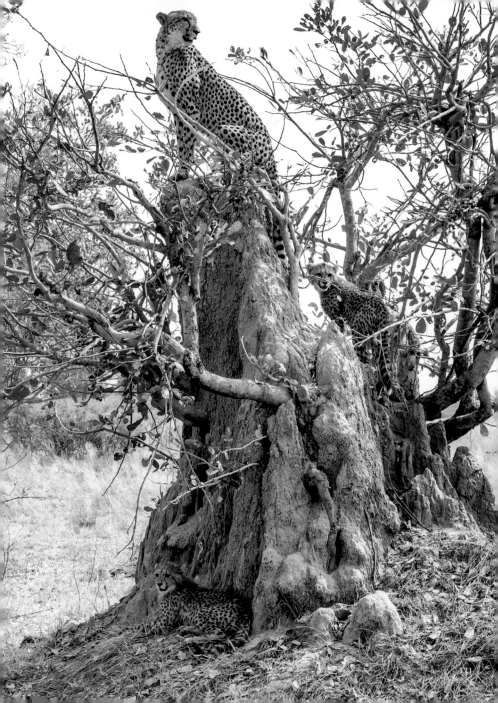

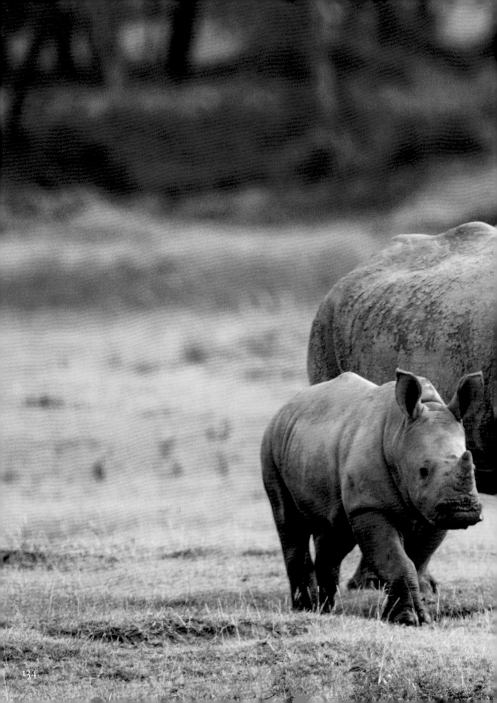

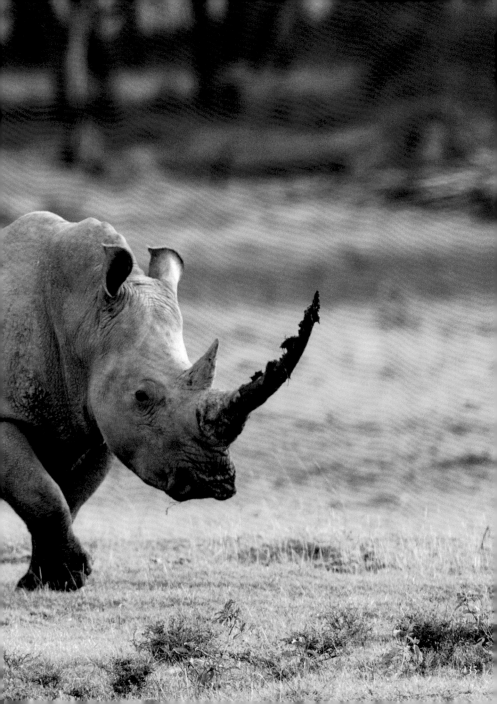

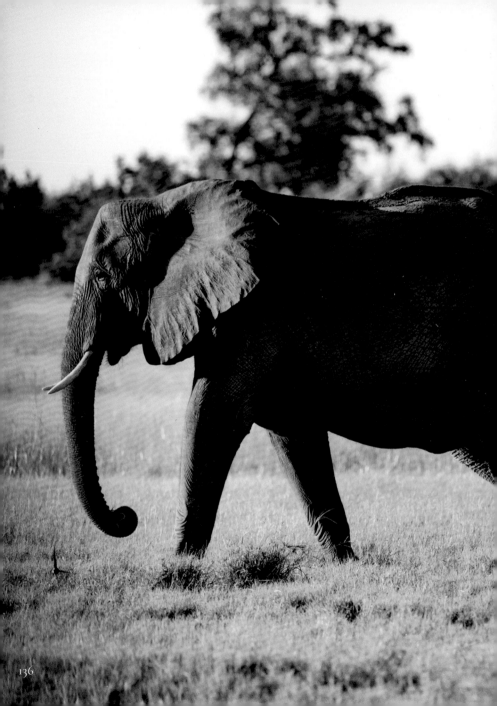

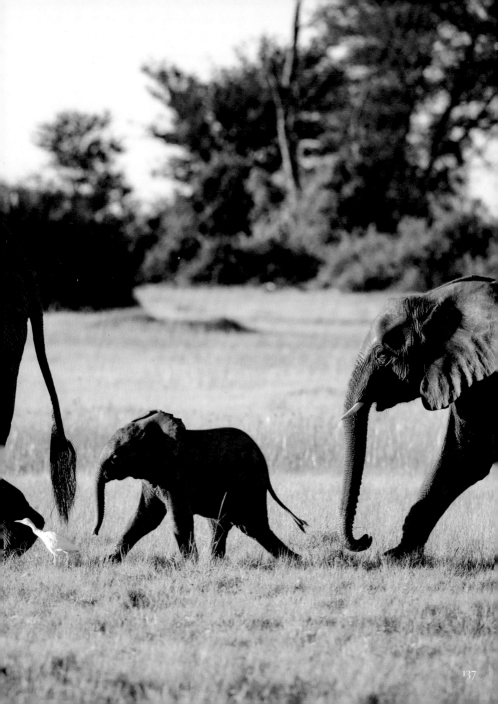

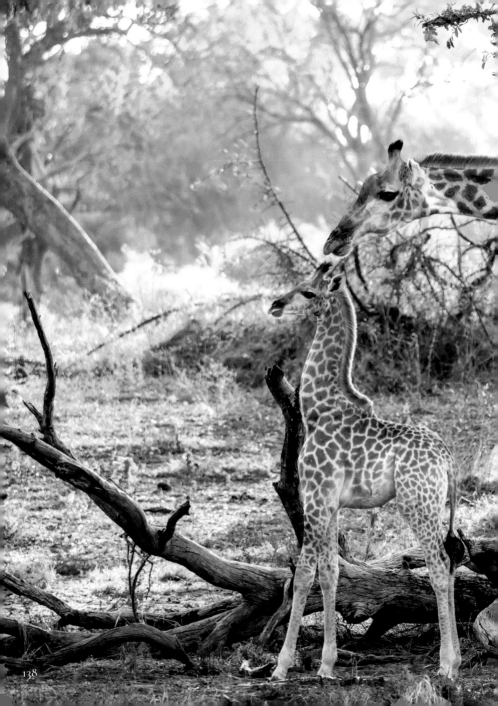

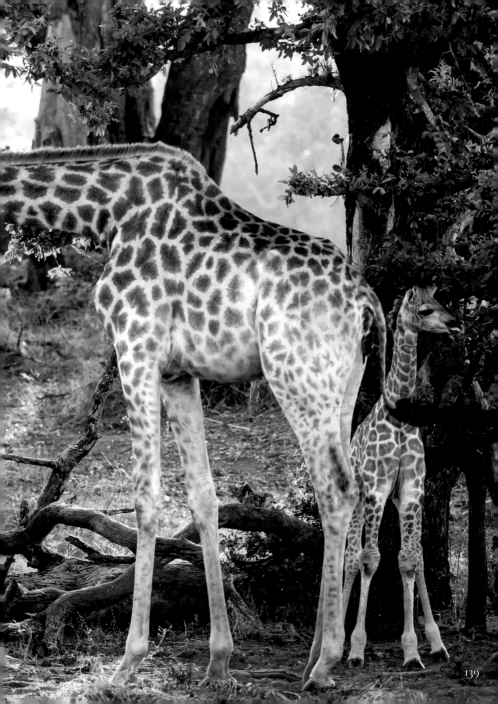

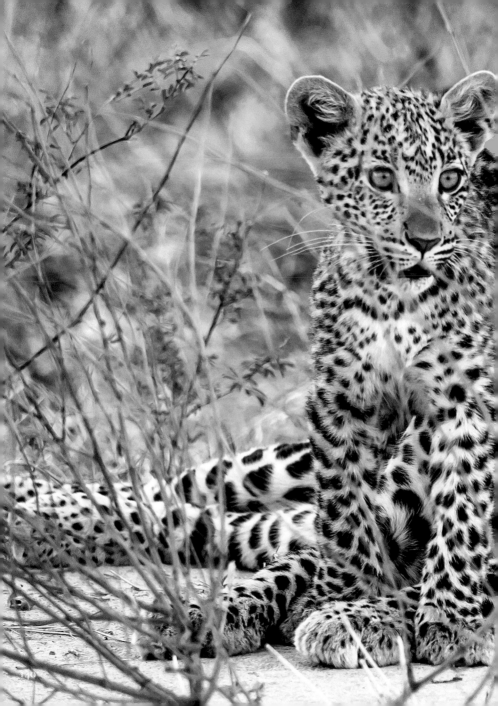

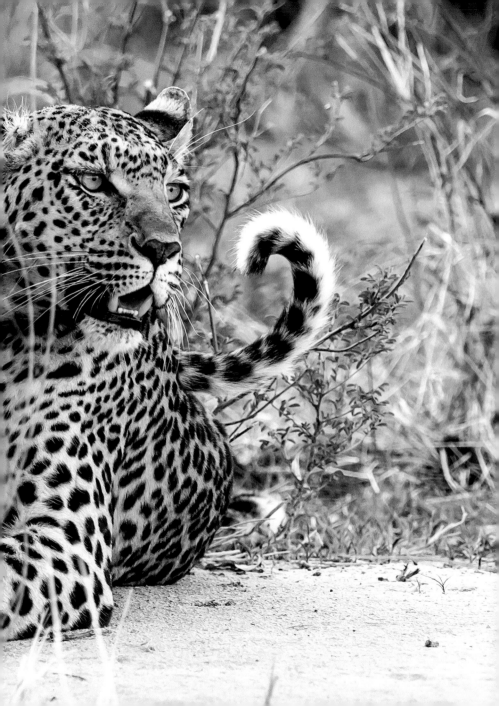

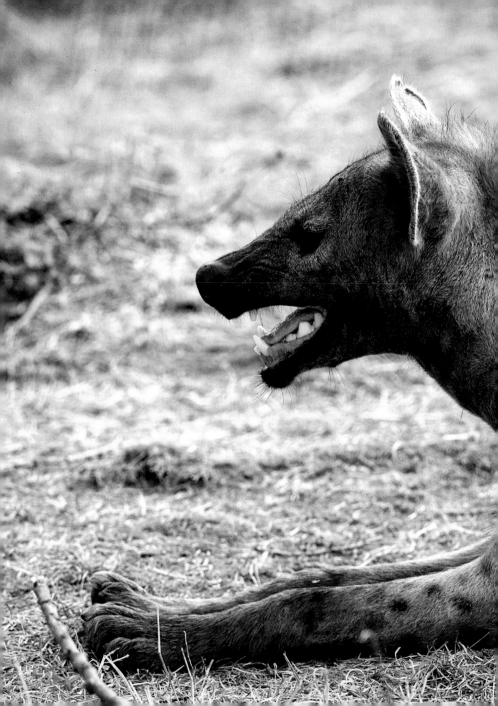

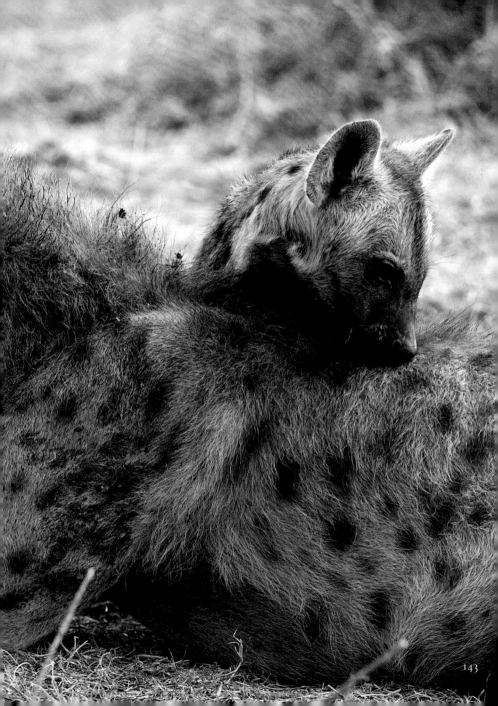

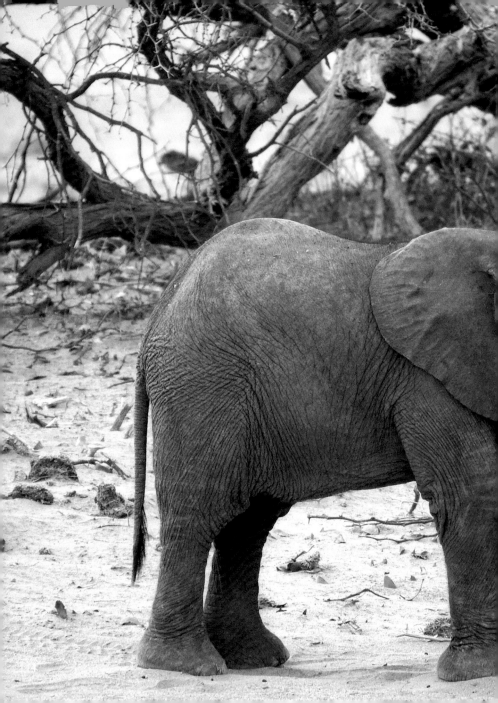

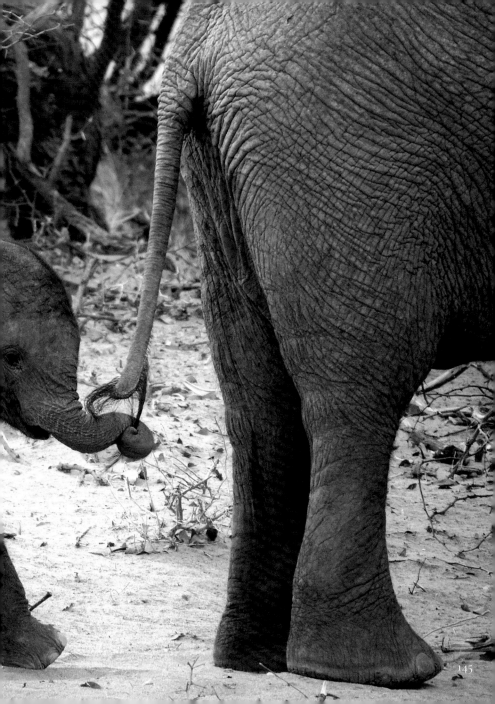

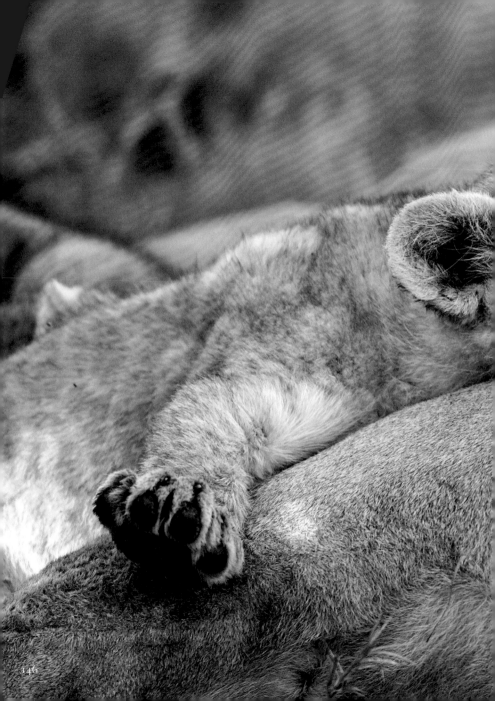

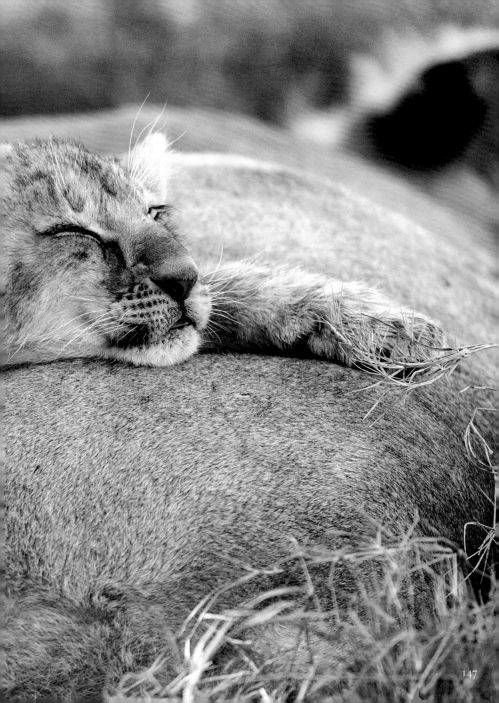

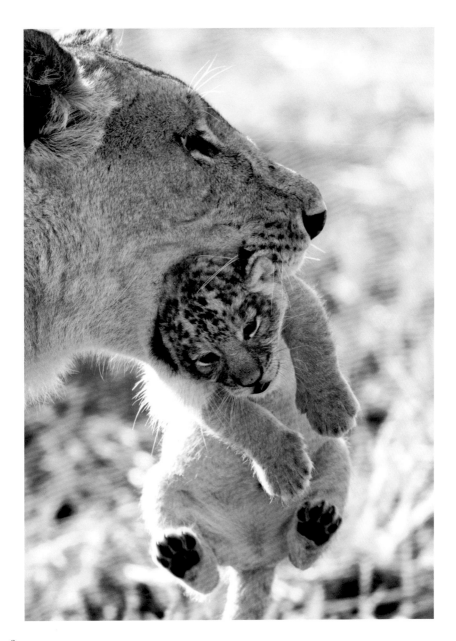

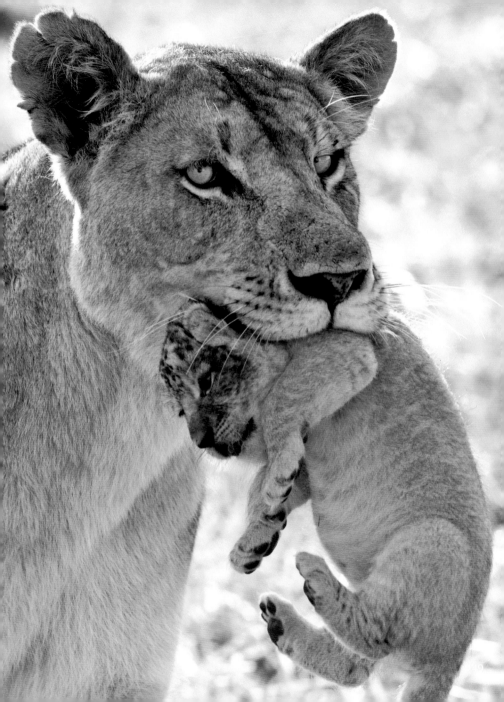

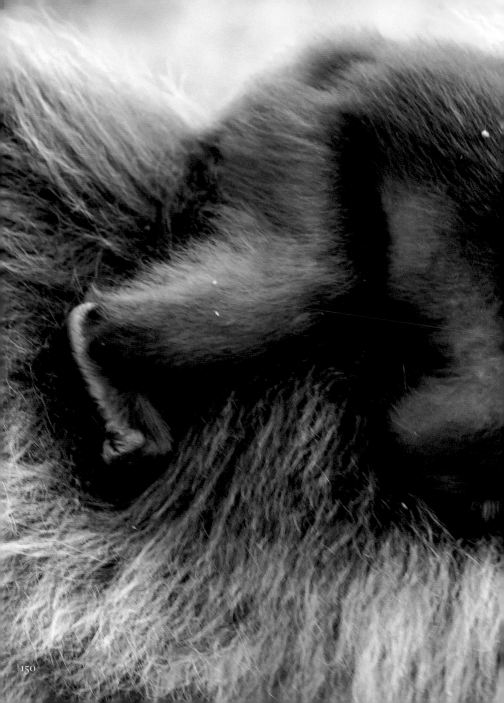

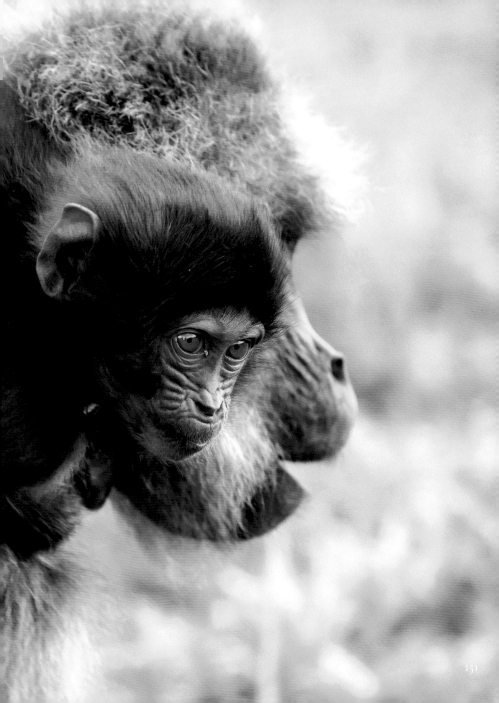

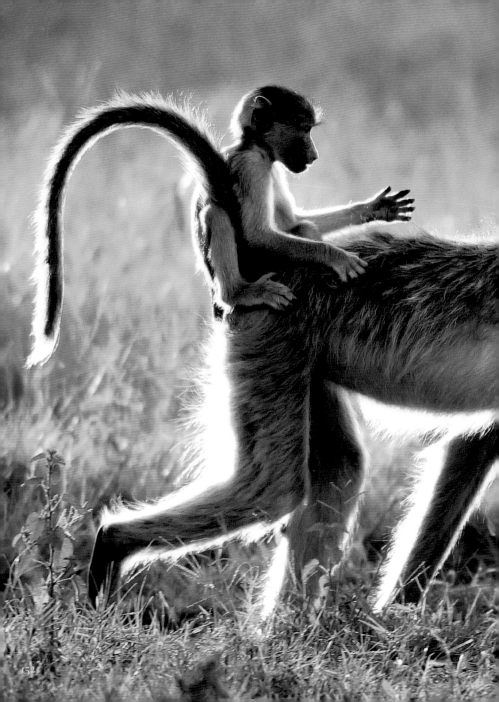

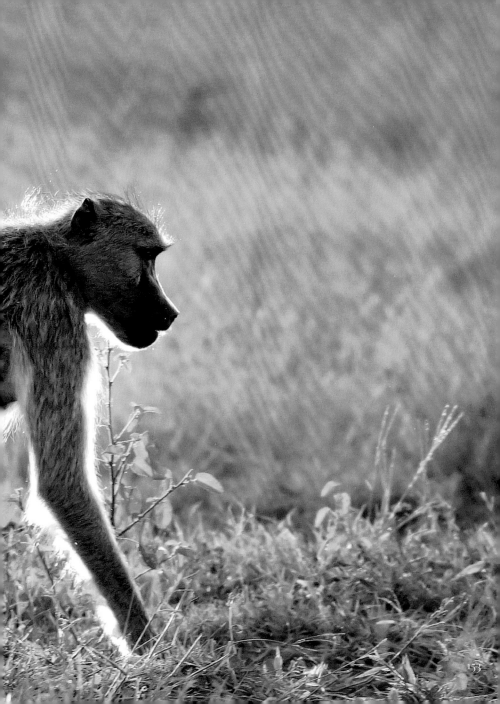

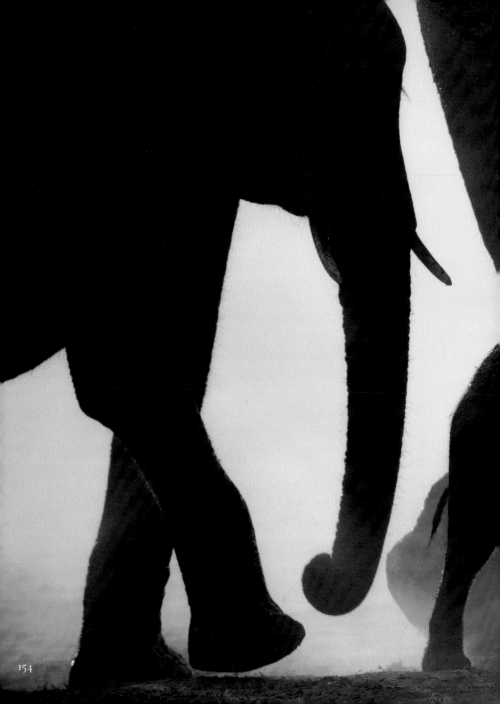

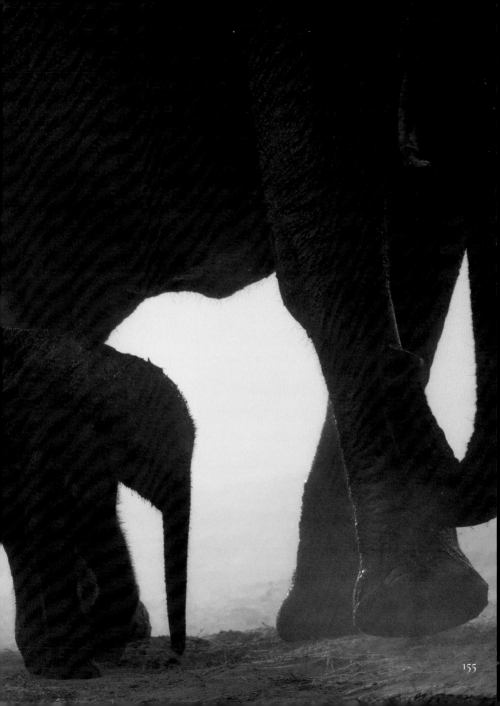

INDEX

BIOGRAPHY

Life always shows Michael Poliza new paths: from actor to entrepreneur, from professional photographer to travel designer. After a career in the IT and Internet industries, Poliza started a three-year multimedia expedition on a ship around the world. He has been considered a digital photography pioneer ever since his bestseller on the Starship expedition was published. In 2002, he returned to the continent that stole his heart: Africa. The book, entitled AFRICA, appeared in July 2006 and is one of the most talked about photography titles of its time. In late 2006, Poliza embarked on a new photographic adventure: an eight-week helicopter trip from Hamburg to Cape Town, flying down the east coast of Africa, with the goal of making the continent something everyone could experience from a birds-eye perspective, documented in EYES OVER AFRICA. After his exciting photo safaris in Africa, Poliza traveled to the Arctic and Antarctic, which he captured for his book ANTARCTIC, an homage to life in the polar regions. Recognized for his dedication to nature and wildlife around the world, he was nominated Ambassador of the World Wildlife Fund (WWF) in 2009.

Upon his return to Hamburg in 2009, Michael opened a gallery, giving at least his photography a permanent home. Unable to stay away from Africa for too long, he returned to the continent for his next books SOUTH AFRICA, CLASSIC AFRICA, and KENYA. Captivated by the beauty and uniqueness of his work, friends of Poliza began to ask if they could accompany him on his expeditions. Never tired of accepting new challenges, he founded the company MICHAEL POLIZA PRIVATE TRAVEL in 2011, which tailors very special adventure trips to the most beautiful and untouched places. In his 2015 book, THE WORLD'S MOST MAGICAL WILDERNESS ESCAPES, Poliza shares 20 of his absolute favorite destinations, allowing his readers to come along on these tours. Impressive photography paired with useful information make this volume a unique experience. In 2017, Poliza published his book MALLORCA and in the following year, 2018, two more books: NAMIBIA, another tribute to Africa, and ISLAND, exploring the country of Iceland.

OTHER TITLES
BY MICHAEL POLIZA

EYES OVER AFRICA
Special Selection
25 x 32 cm / 9 ⁵/₆ x 12 ³/₅ in.
304 pages
ISBN 978-3-96171-037-9

NAMIBIA

29 x 37 cm / 11 ²/₅ x 14 ¹/₂ in.
280 pages
ISBN 978-3-96171-128-4

THE WORLD'S MOST MAGICAL
WILDERNESS ESCAPES
25 x 32 cm / 9 ⁵/₆ x 12 ³/₅ in.
224 pages
ISBN 978-3-8327-3238-7

MALLORCA

25 x 32 cm / 9 ⁵/₆ x 12 ³/₅ in.
224 pages
ISBN 978-3-8327-6921-5

W W W . M I C H A E L P O L I Z A . C O M

© 2018 teNeues Media GmbH & Co. KG, Kempen
Photographs © 2018 Michael Poliza.
All rights reserved.

www.michaelpoliza.com
www.michaelpolizatravel.com

Foreword by Victorine Lamothe
French translation by Tina Calogirou,
proofreading by Claude Checconi
Design by Sophie Franke
Editorial coordination by
Arndt Jasper & Emma Molloy
Production by Sandra Jansen-Dorn
Color separation by Jens Grundei

ISBN 978-3-96171-141-3

Library of Congress Number: 2018904693

Printed in Slovakia

Bibliographic information published by
the Deutsche Nationalbibliothek
The Deutsche Nationalbibliothek
lists this publication in the
Deutsche Nationalbibliografie;
detailed bibliographic data are available
on the Internet at http://dnb.dnb.de.

FSC
www.fsc.org
MIX
From responsible
sources
FSC® C023577

Published by teNeues Publishing Group

teNeues Media GmbH & Co. KG
Am Selder 37, 47906 Kempen, Germany
Phone: +49-(0)2152-916-0
Fax: +49-(0)2152-916-111
e-mail: books@teneues.com

Press department: Andrea Rehn
Phone: +49-(0)2152-916-202
e-mail: arehn@teneues.com

teNeues Media GmbH & Co. KG
Munich Office
Pilotystraße 4, 80538 Munich, Germany
Phone: +49-(0)89-443-8889-62
e-mail: bkellner@teneues.com

teNeues Media GmbH & Co. KG
Berlin Office
Kohlfurter Straße 41–43, 10999 Berlin, Germany
Phone: +49-(0)30-4195-3526-23
e-mail: ajasper@teneues.com

teNeues Publishing Company
350 7th Avenue, Suite 301, New York,
NY 10001, USA
Phone: +1-212-627-9090
Fax: +1-212-627-9511

teNeues Publishing UK Ltd.
12 Ferndene Road, London SE24 0AQ, UK
Phone: +44-(0)20-3542-8997

teNeues France S.A.R.L.
39, rue des Billets, 18250 Henrichemont, France
Phone: +33-(0)2-4826-9348
Fax: +33-(0)1-7072-3482

www.teneues.com